FRIDA KAHLO

The Camera Seduced

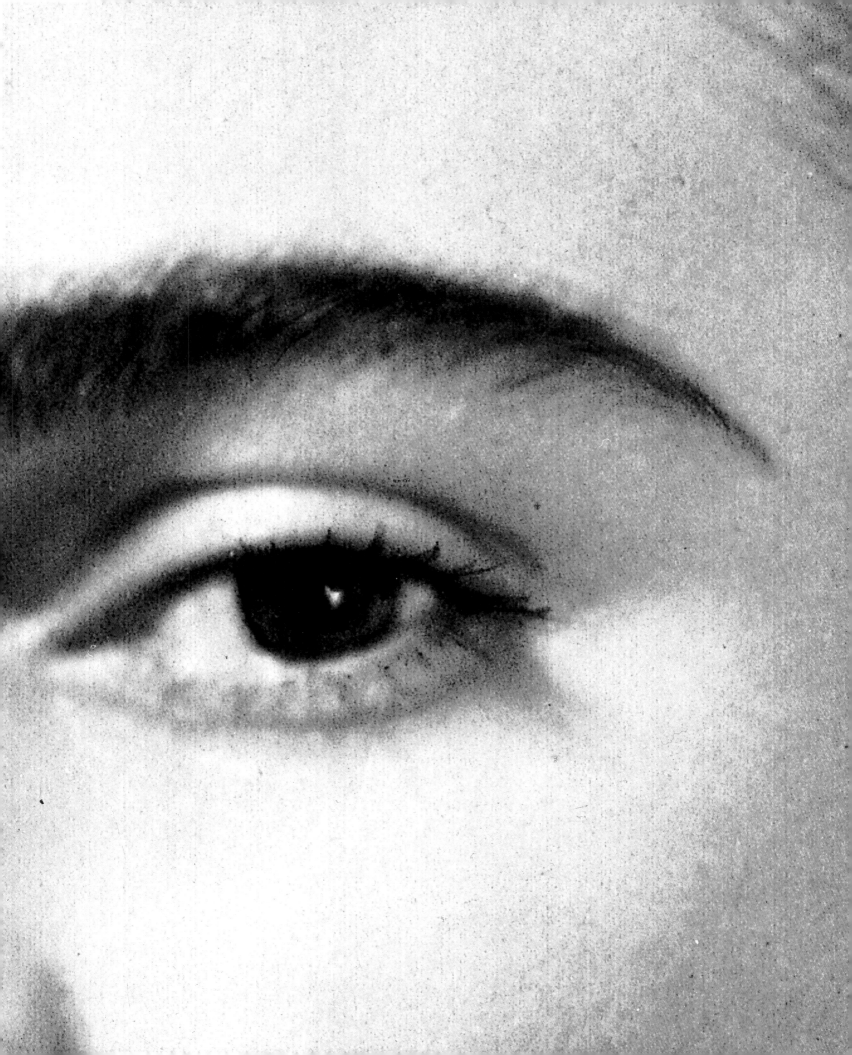

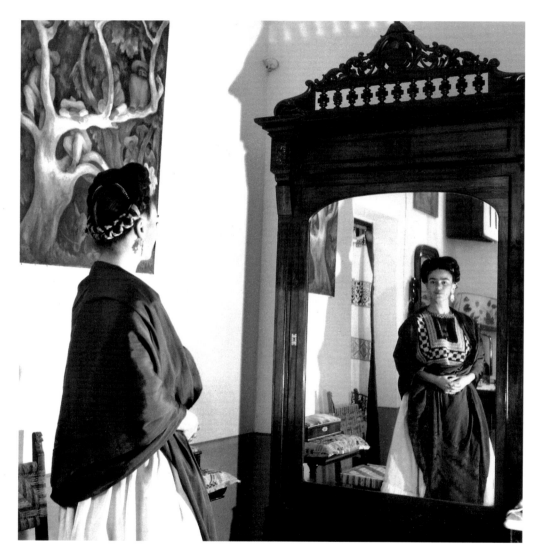

Lola Alvarez Bravo, 1947, Coyoacán, Mexico

FRIDA KAHLO

The Camera Seduced

Photographs by

Ansel Adams, Lucienne Bloch, Lola Alvarez Bravo, Manuel Alvarez Bravo,
Imogen Cunningham, Guillermo Davila, Gisèle Freund, Hector Garcia,
Juan Guzmán, Fritz Henle, Peter A. Juley & Son, Antonio Kahlo, Guillermo Kahlo,
Bernice Kolko, Leo Matiz, The Brothers Mayo, Nickolas Muray,
Emmy Lou Packard, Victor Reyes and Family, Diego Rivera, Bernard Silberstein,
Edward Weston, and Guillermo Zamora

Memoir by Elena Poniatowska

Essay by Carla Stellweg

A Lookout Book

Chronicle Books San Francisco

CONTENTS

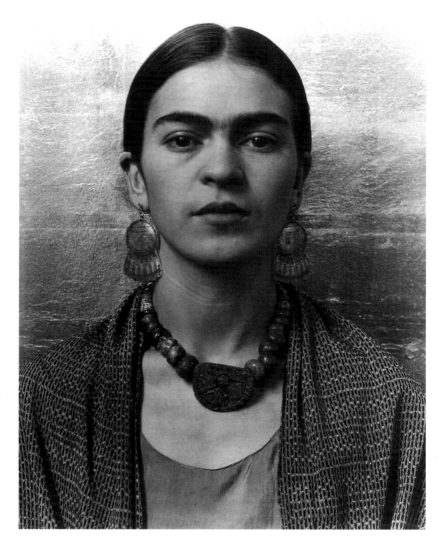

Imogen Cunningham, 1930, San Francisco

DIEGO, I AM NOT ALONE: FRIDA KAHLO

Elena Poniatowska

What you see is falsehood. Under the unsmiling lips, a row of rotten teeth lies black. The high brow, crowned with braids interwoven with colored strands, hides death, the same death that has run through my skeleton since I was stricken by polio. Look at me well because it might be for the last time. Look at my sleepless eyes, look at them. I never rest, or almost never. Day and night, I am alert, I hear things that others don't see, look at me, I am a hammer and a pinned butterfly congealed in flight. Ignacio Aguirre, the painter, my lover, wrote this. I awake terrified, covered with sweat, as if I had died in my sleep. Dawn brings small comfort, for pain persists. But the light on the blue walls of my house in Coyoacán is so limpid, so clean, I must paint, I must live.

Do you see my ring-covered fingers? I kiss my palms, I kiss my fingers, I cherish them, they haven't failed me, they obey the orders of my brain even though my whole body rebels. Under the skin that wraps me, the lymph, blood, fat, humors and flavors are doomed to punishment, and so it has been since I was six. My body, a Judas, has sold me out and in Mexico the images of Judas are burned, they explode in the sky and are reduced to ashes. Every year, every Easter, every Holy Friday, the same ceremony, the burning of Judas, a remembrance of treachery.

The hands you see sticking flowers in my long black hair so that the poet Carlos Pellicer could write, "You are nailed with flowers," are the same hands that have embraced Diego, my frog-king, have pinched the nipple of a desired woman, have pulled the cover over my body to keep out the cold, and, above all, have held the brush. They have mixed the colors on the palette, drawn my parrots, my dogs, my abortions, my Indian wet-nurse, the little faces of children, the eyebrows of my father Guillermo. They have written a diary, sent love-notes, and scribbled grocery lists. These hands have picked up scissors and cut my hair, spewing black strands onto the floor. They have dressed me like a man, and have buttoned my fly, and

Diego and I, 1949. Oil on canvas, mounted on masonite. 11⅝ × 8⅝ inches. Mary-Anne Martin/Fine Art, New York.

copied the song, "I loved you because of your hair, now that you have cut it, I don't love you anymore."

I paint everything: my lips, my blood-red fingernails, eyelids, my earlobes, my eyelashes, my eyebrows. I tattooed my corsets, one after another. I drew my birth, my dreams, my toes, my navel, my nudity, my blood, my blood, my blood. The blood that left my body and came back into it, the Judases around me, the Judas that watches my sleep, the Judas that is within me. I paint myself over and over again. Two of me exist, and as I paint I exorcise the wounded, second Frida. Since childhood I realized that I had to protect one of my demons, for if I emptied myself of her, I would be a dead Indian. My father warned Diego, "She has two demons inside."

The person who you see looking at herself in the mirror, glancing at the garden, caressing a deer, smoking, emerging from the canvas is I. My name is Frida Kahlo. I was born in Mexico, it doesn't suit me to say when. I never told my first love Alejandro Gómez Arias my age; he was younger than I.

I am afraid to lose those I love, I don't want anyone to leave, I want to be surrounded. If people come and go, at least I have my dogs, my parrots, my monkeys. I want everyone to be there and I want them to turn and look at me, to look at me. I exist in the reflected light of others.

To be like others is a bore. Even as a child I wanted to be distinct, to be different, to be adored. First by my father, then by Alex, who never really loved me, and by my schoolmates, the *Cachuchas.* I wanted to be loved by the brilliant blue sky, the watermelons in the market, the wistful eyes of animals; I was going to make the world fall head over heels in love with Niña Frida.

I always knew there was more death than life in my body. When you are sick you are isolated. "In jail and in bed, you discover your friends." I fell ill, *zass!*, one morning I couldn't stand, *zass!*: poliomyelitis. The doctor diagnosed a "white tumor." Nine months in bed. They washed my leg with walnut water and hot compresses. No one knew what to do. All doctors are asses. My father helped me. He gave me paints and made a special easel so I could draw in bed.

I wore orthopedic shoes and at school the children shouted, "Frida, pegleg, Frida, pegleg." I didn't realize that their taunting would hurt so much.

Guillermo Kahlo, my father, protected me. He was the first to really love me. He was epileptic. I followed him as he went about photographing churches and monuments because

I knew how to take care of him when he had an attack. I gave him a whiff of ether, put my finger under his tongue, wiped away the foam, sprinkled him with water, and kept an eye on the camera lying at his side. To have it stolen would have been a disaster. We were poor and to buy another was impossible. After an attack he said nothing. Very quiet, my father. He never spoke about his sickness. What for? His customers respected him because he knew what his work entailed and he did it very well.

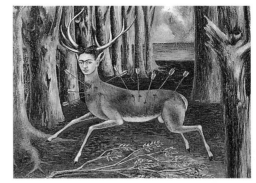

The Little Deer, 1946. Oil on masonite. 9×12 inches. Collection of Espinosa Ulloa, Mexico City.

When I was seven, I helped my fifteen-year-old sister, Matilde, to elope with her lover. Ever since then, I have believed in love. Balconies must open for women to fly out. I flew after Diego. I have flown after all men and women who have attracted me.

When my mother found out that her beloved daughter, Matilde, had escaped, she became hysterical. She was frustrated and neurasthenic. Sometimes I hated her. Mother caught mice in the basement and drowned them in a barrel of water. Once she showed me a letter from her first admirer, a young German boy like my father, who committed suicide before her eyes. She never forgot him. I don't think she was in love with my father.

On the 17th of September, 1925, my life changed forever. Until then, my thin little leg never pained me, but the streetcar and bus accident fucked up everything. As a result of the tremendous impact, a handrail pierced through my body. When I came to, I was on a billiard table. I lost consciousness again when a man took hold of the rail and pulled it out of my guts. Alex, who had been sitting next to me on the bus, told me later that when he saw me I was drenched in blood and gold dust. A passenger, at the moment of the crash, dropped his package of gold dust and it covered me. I was taken to the Red Cross Hospital and the diagnosis was: "fracture of the third and fourth lumbar vertabrae, three fractures of the pelvis, eleven fractures of the right foot, dislocation of the right elbow, deep wound in the abdomen produced by a metal bar that penetrated through the left hip and came out through the vagina, tearing the left lip. Acute peritonitis. Cistitis. A drain is indicated." The doctors couldn't believe I had survived. I lost my virginity, my kidney was affected, I couldn't urinate. My greatest complaint was the pain in my spine.

My family was horrified, they couldn't face seeing me. Only my sister Matilde came to visit. I saw my mother after three months and told her, "I haven't died and I have something to live for: painting."

Painting was my only true medicine. It completed my life. I had three miscarriages.

17

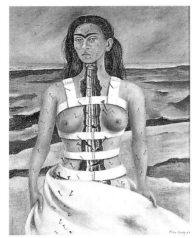

The Broken Column, 1944. Oil on masonite. 15¾ × 12¼ inches. Collection of Dolores Olmedo Foundation, Mexico City.

Painting substituted for the babies I never had. The only therapy is work.

The last day of April, 1927, I wrote to Alex: Friday they put the cast on and since then I have lived in excruciating martyrdom that cannot be compared to anything else. I felt I was suffocating, an awful pain in my lungs and back, I could barely walk, and I couldn't sleep at all. They hung me from a beam for hours and after that made me stand on my toes. They put me in traction with weights and my spine became more and more fragile, they stretched my neck like an ostrich. I heard the sound of the bones protesting, I was not allowed to move for months, and after all that, I was no better. All of this suffering for nothing. I did not want to live nor did I want to die. I wanted to paint and to make love.

Every time a new corset was cast, they blew hot air on me to dry it. However, when I came home, it was still damp. I suffered horribly. At first the doctors said I had to be in the cast for months, but, one after another, I stayed in them for years.

The Frida that I have inside is only known to me. Only I can tolerate her. She weeps, she has fever, she's in heat, she's ferocious, full of desires: for a man, for a woman, desire that exhausts. Desire wears you down, empties you, makes you useless. I lost my life and regained it many times. Life came back drop by drop as if by transfusion, a kiss from Diego, his mouth on mine. Life left me again in another operation. During thirty years I have had thirty-two operations. In the last one they amputated my leg. "Feet why do I need them if I have wings to fly." When Diego left me, life left me, but I was willing to give him my life.

I tell all this because I have never been able to keep things inside. As I wanted to explain this to others, I began to paint self-portraits: my face, my body, my broken spine, and the arrows in the skin of the deer. I dressed my monstrous Judases in my own and Diego's clothes, and I hung them from my bed from the rafters, just as doctors have made me hang with sacks of sand bags attached to my extremities. I also hung a tinkling bell in August, 1953, to my new artificial leg on top of a red boot.

My corsets, how many corsets! Leather, steel, plaster. I painted them with gentian blue, then with iodine, pharmacy colors. I wanted to adorn the corsets, make them look obscene, because my wounded body was a shitty torture.

When I married Diego, warm happiness came to me! We laughed, we played together, we ate with the same spoon. He was enthralled with my painting. We admired, we respected each other. I was the distinguished Lady Doña Frida Kahlo de Rivera. We traveled, made fun

of the gringos, our two sexes were wrapped with roots, we were indecent, my wounds grew into flowers. But there has always been a thorn in my life. Diego was the great big macho, he had other loves, and I was a devouring woman. I became a great big macho, I took and rejected, I pursued the one I wanted, I was a violent and a tender lover. Diego, I am alone, Diego, now I am no longer alone. In *Gringolandia* I had exhibitions of my paintings, the *gringos* went crazy over my shows, they are crazy anyway and half-baked, they come raw out of the oven, I became a show-off, I wanted to look

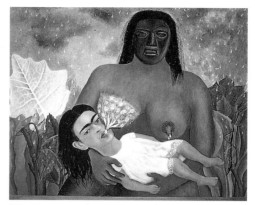

My Nurse and I, 1937. Oil on sheet metal. 11¾ × 13¾ inches. Collection of Dolores Olmedo Foundation, Mexico City.

spectacular everywhere, but deep down, every step I took was fucking hard. I laughed out loud, I brayed like a donkey, great *carcajadas*, throwing my head back so no one could see my teeth hidden by my tongue. The devil within me burst out in spells of laughter in order not to cry out in pain. I'm a real smart bitch.

When my first damn good exhibit opened in Paris in the Galerie Pierre Colle, organized by Andre Breton, I began to drink great quantities of booze, cognac after cognac. Every night I drank myself to sleep. I was always slim but now I began to bloat. As I drank, I forgot my wretchedness. Imagine how silly: while I was swaggering through the streets, the imbecilio French high fashion designers saw my long *Tehuana* skirts and petticoats, my ruffles, ribbons, and *rebozo*, and designed their own version: a dress named *Robe Madame Rivera*. I was pleased to appear in *Vogue*. The French people told me I was extravagantly beautiful. In Mexico, no one ever turned to look at me in the streets. For them, I was just a gimp.

In 1940, in San Francisco, Doctor Eloesser forbade all alcohol and with this the possibility for me to evade reality. In 1946, Doctor Philip Weston fused four lumbar vertabrae and transplanted a piece of pelvis into my spine. I was in bed for three months. When I took my first step, I felt almost normal, what a wonder! He warned me not to overdo it, but I didn't listen. I came and went, and the consequences were catastrophic. I was never prudent, never obedient, never submissive, always a rebel. When I was young I threw myself down on the ground in rage. I would still do it if my spine wasn't such an idiot. I kept a picture of Stalin under my pillow but I was contradictory. I went to meet Trotsky and Natalia Sedova in Tampico harbor and welcomed the couple to my blue house in Coyoacan. He lived between my heavenly walls until we became neighbors, Trotsky and Natalia Sedova in Viena Street, Diego and I in Londres Street.

Little by little, I regained strength. When the *pulqueria* "La Rosita," painted by my students, was inaugurated, I was determined to walk there without a corset. No corset! If it meant never to get out of bed again, I was going to be part of the fiesta, talk to everyone in the street, see new faces, be free. My hair fell loose, my skirts swished, my breath came in gasps, but I made it! Real color flushed my excited face. I sang as others danced.

The woman you see in the wheelchair, next to Doctor Juan Farill, who cut off my paw, is Diego's lover, mother, daughter, sister, protector, guide. Diego realized this and painted himself as my little boy in his mural *A Sunday in the Alameda Park*. I am always present in his subconscious. As all children, he is unreliable. To others, he declared my painting was unique.

I have always painted with care, over and over, until the tones glow. I draw each little hair of my monkeys with fleas on top, each little hair of my moustache. Every gland in my nurse's breasts, heavy with milk, are finely traced. The roots and vines of plants and flowers intertwine and find their way into the earth. Fruits become very tempting and lush. Mexico is an extraordinarily creative country, an indomitable life force. Mexico is luscious, erratic, self-indulgent. Mexico is the portrait of Diego.

I wouldn't have spent my life in hospitals if God existed. I wouldn't have taken an incredible amount of drugs. If He existed, I would have run through His world, and jumped in the air, and danced to the sea. My father would not have been an epileptic. I would have born a son to Diego, carried him in my arms, and Diego would not have been unfaithful to me, nor I to him.

Look at my face, look at my eyes, much is written there, much is hidden from view. My real self is in my painting.

I hate pity.

Frida's body, surrounded by flames, was cremated on the 14th of July, 1954, while onlookers sang the "Internationale." Frida of the demons. Frida of the blood-covered paintbrush dipped in her own blood, Frida of the necklaces of clay and silver, Frida of the rings of gold: the sorrowful, the critical, the vivacious. Frida, covered in the end by the red and black flag, the red hammer, the red sickle and the white star, continued to be an absolutely passionate communist in heaven.

One Frida has gone, the other is here. The one who stays has a pure brow, full lips, and a profound gaze. No one has been more cowardly than she, no one has been more valiant. Never has there been a woman more vital, never a woman so abandoned, so cruel, and so generous. Friduchita, Friduchin, Frieda, the little Fisita girl.

*When my father took my picture
in 1932 after the accident, I knew that a
battlefield of suffering was in my eyes.
From then on, I started looking straight
at the lens, unflinching, unsmiling,
determined to show that I was a good fighter
to the end. I wrote in my diary a few days before
death: "I hope the exit is joyful, and I hope
never to come back."*

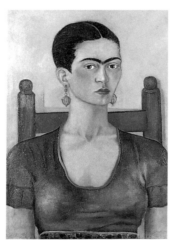

Self-Portrait, 1930. Oil on canvas. 26 x 22 inches. Courtesy Boston Museum of Fine Arts. Private Collection.

PLATES

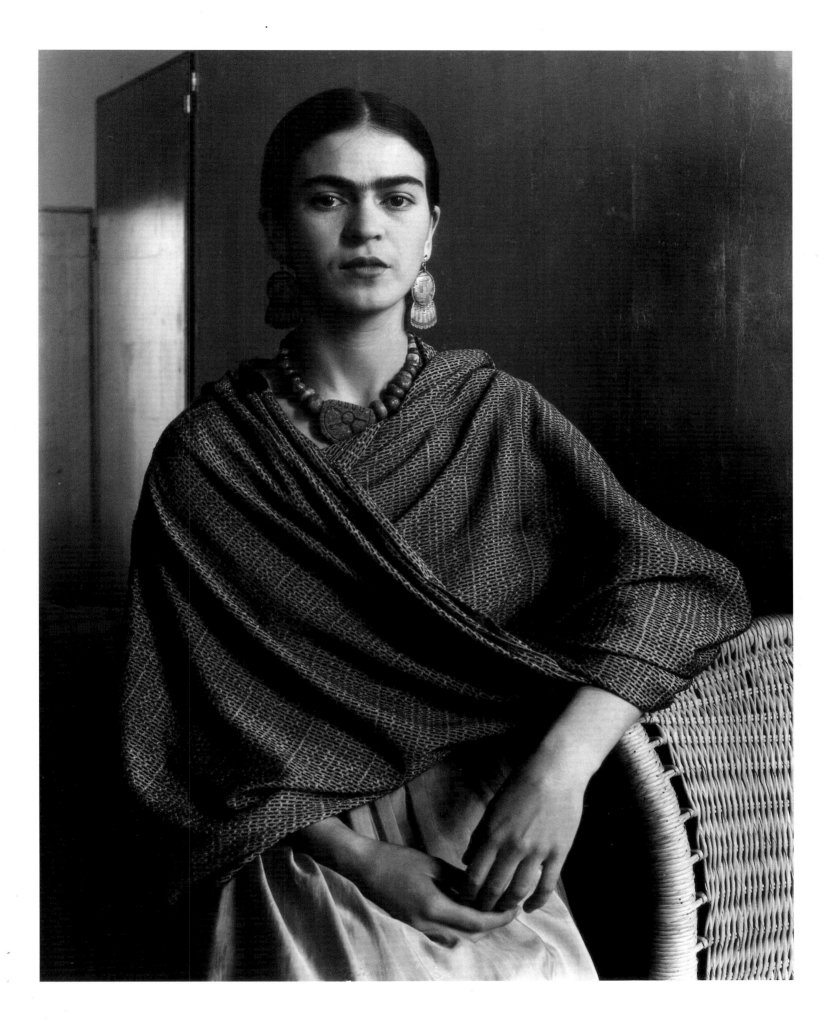

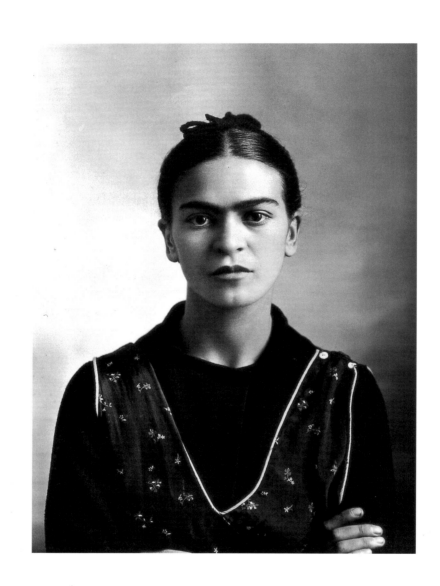

Guillermo Kahlo, 1932, Mexico City

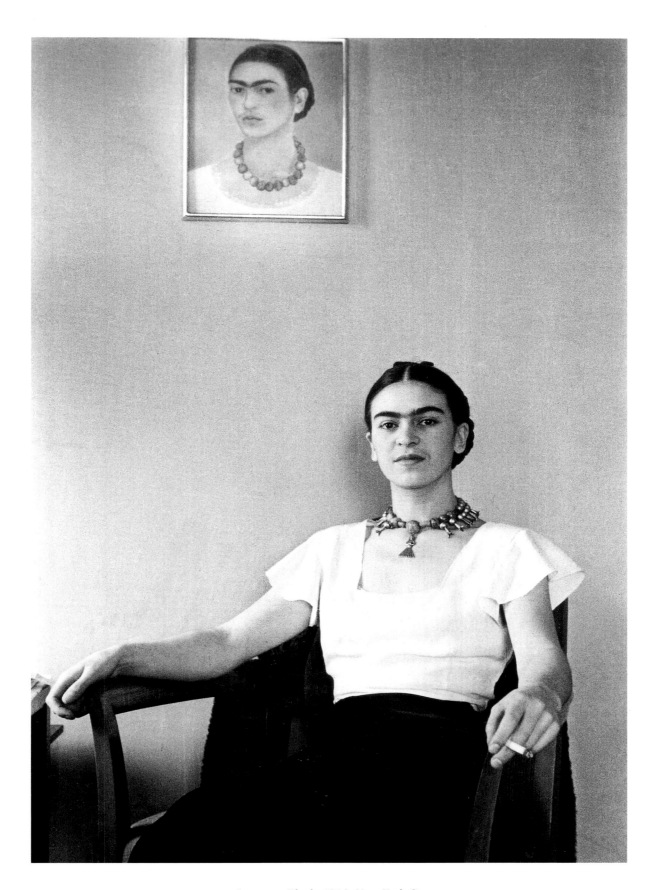

Lucienne Bloch, 1933, New York City

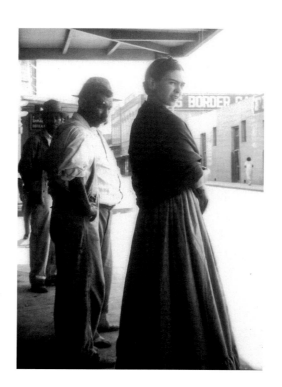

Lucienne Bloch, 1932, Laredo, Texas

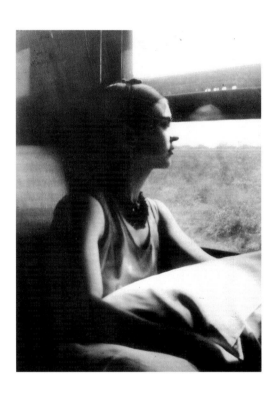

Lucienne Bloch, 1932, En route from Detroit to Mexico

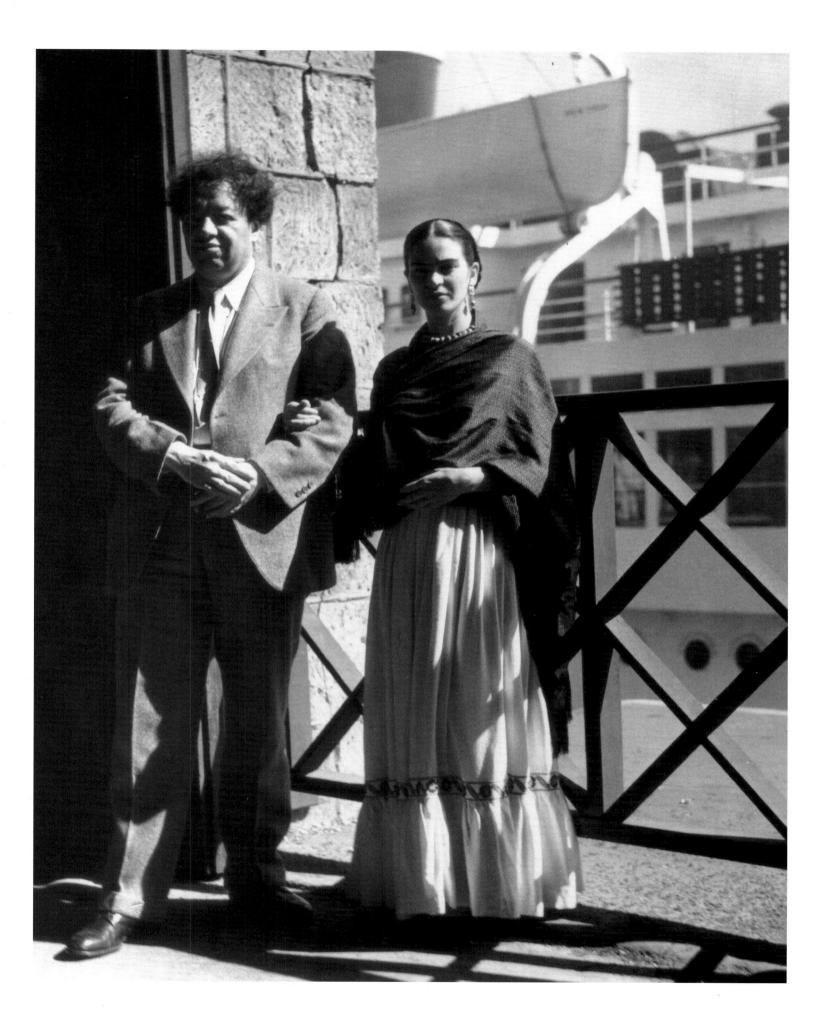

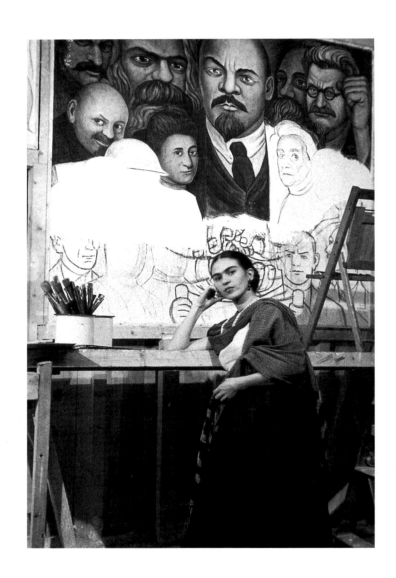

Lucienne Bloch, 1933, New York City

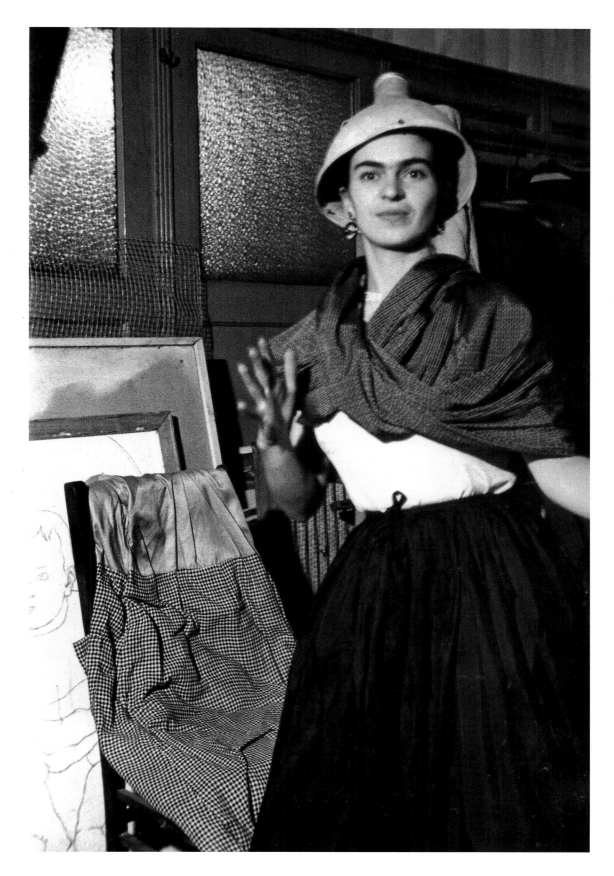

Lucienne Bloch, 1933, New York

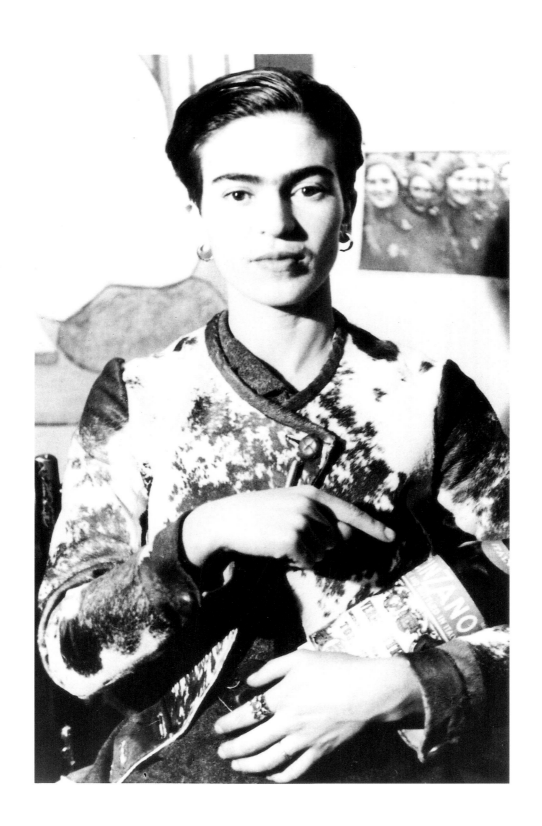

Lucienne Bloch, 1935, New York

34

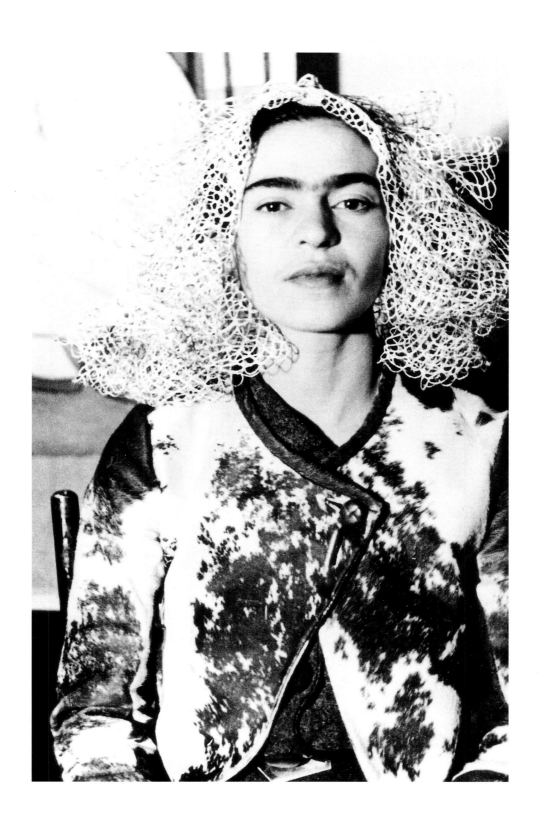

Lucienne Bloch, 1935, New York

Manuel Alvarez Bravo, 1938, Coyoacán, Mexico

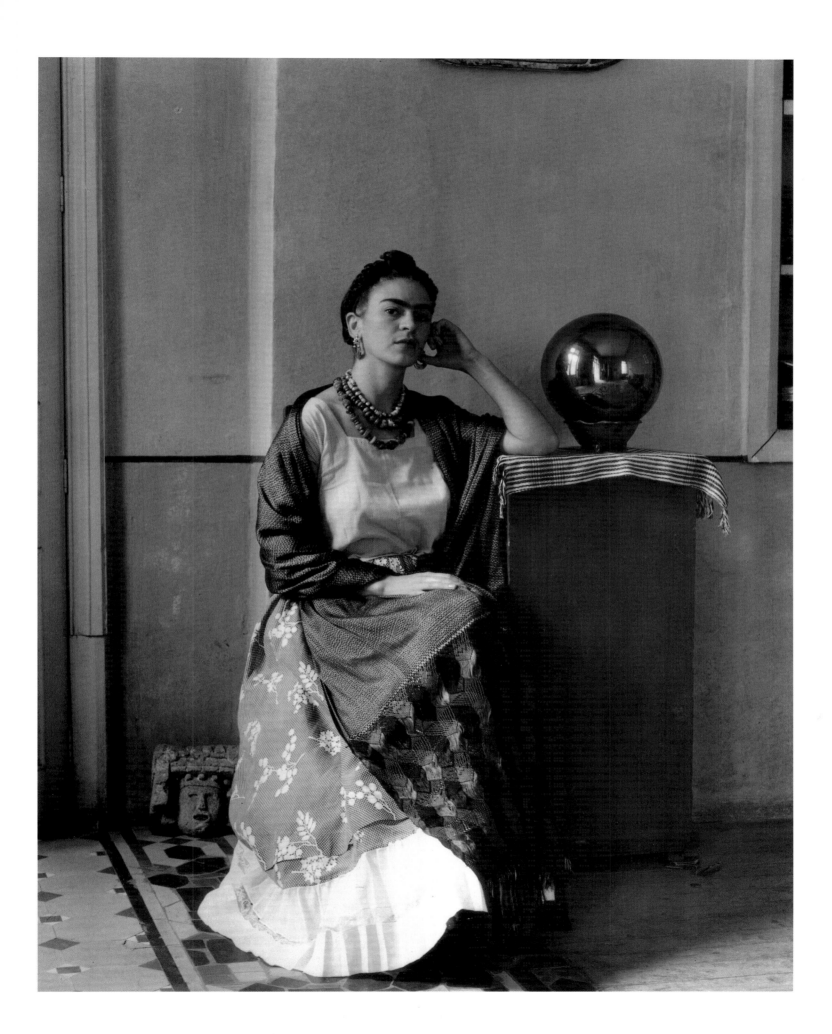

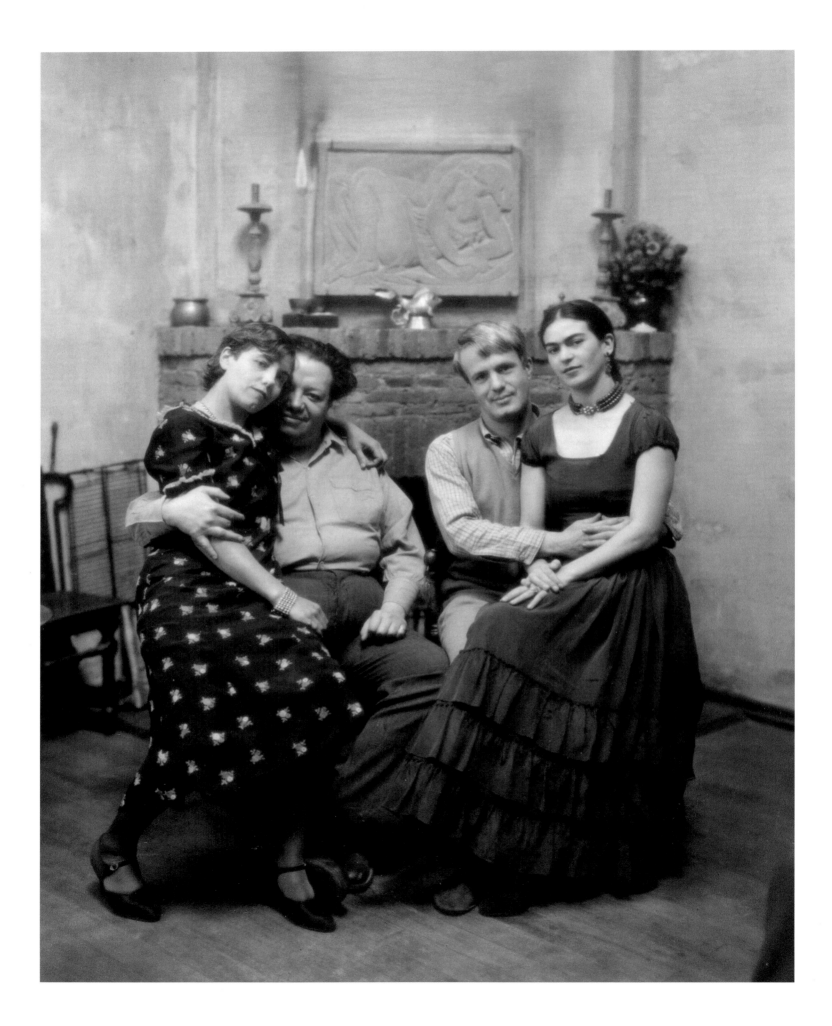

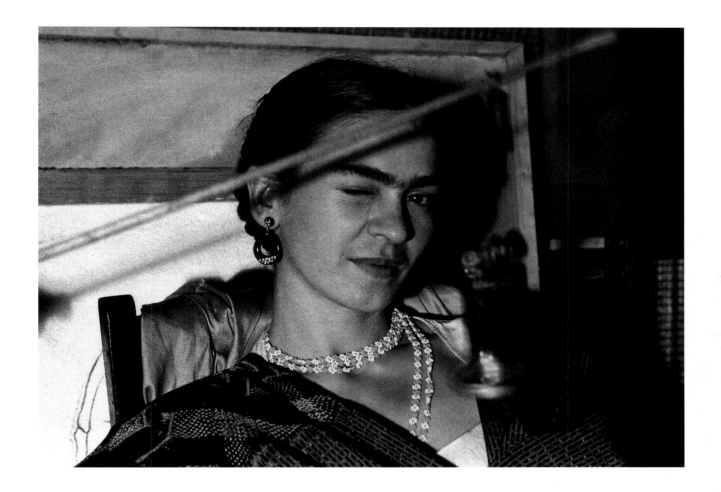

Lucienne Bloch, 1933, New York City

Lucienne Bloch, 1933, New York City

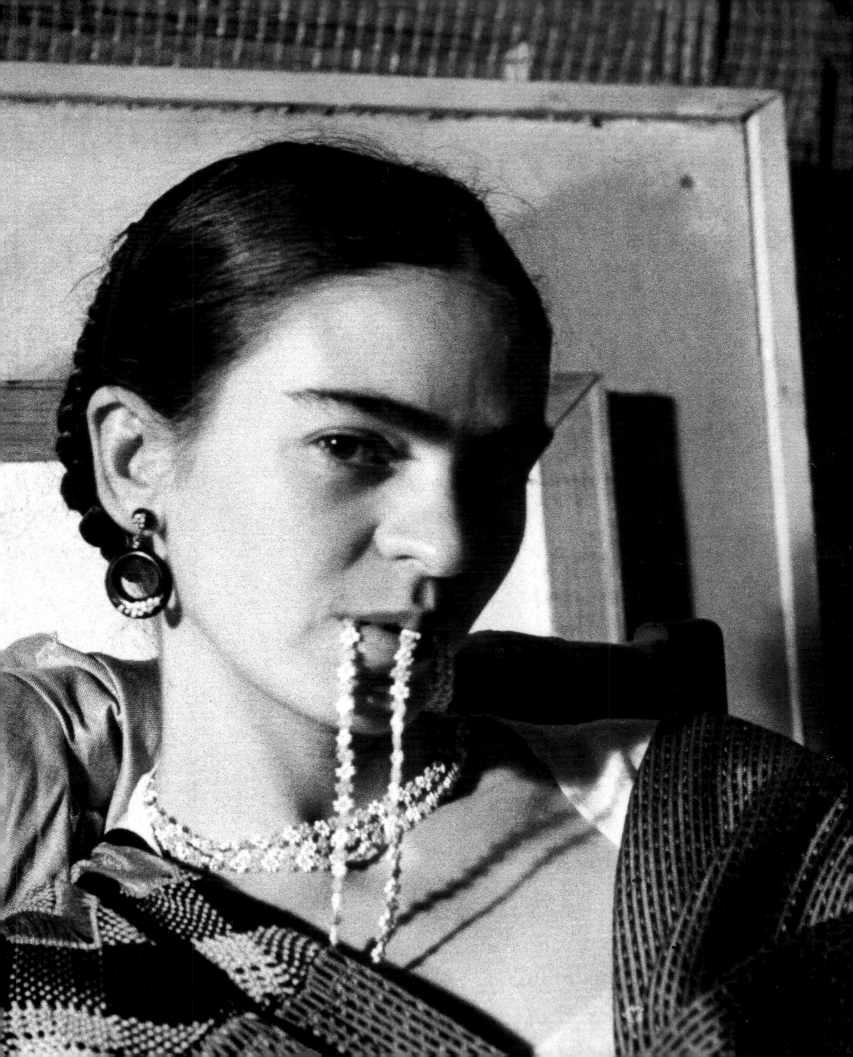

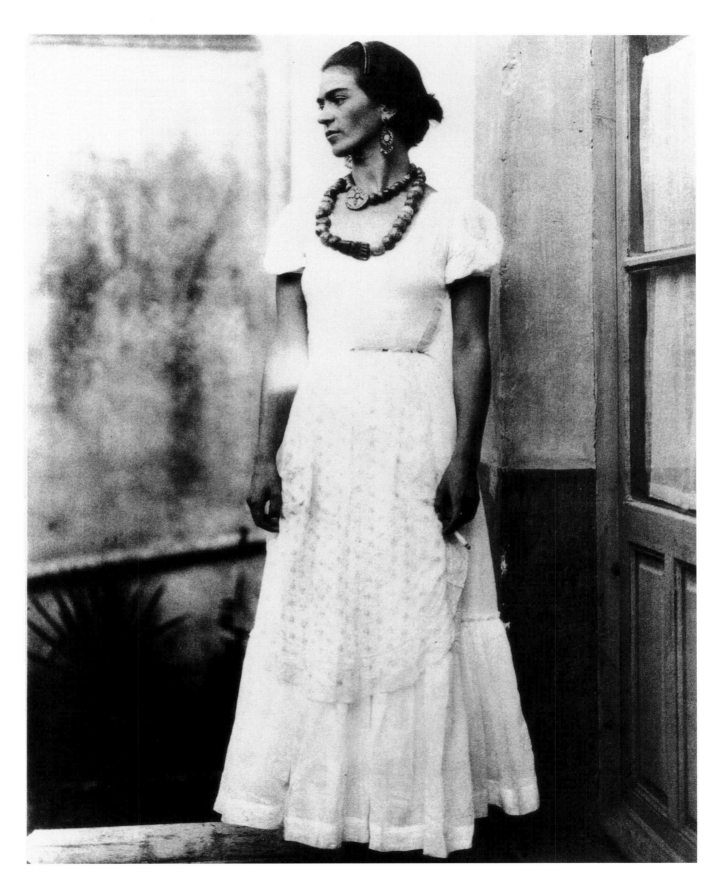

Guillermo Davila, n.d., Xochimilco, Mexico

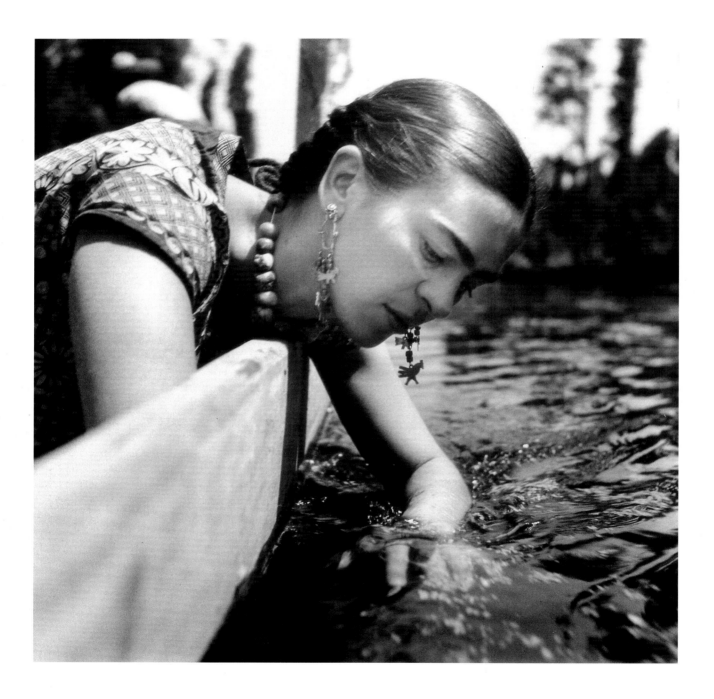

Fritz Henle, 1937, Xochimilco, Mexico

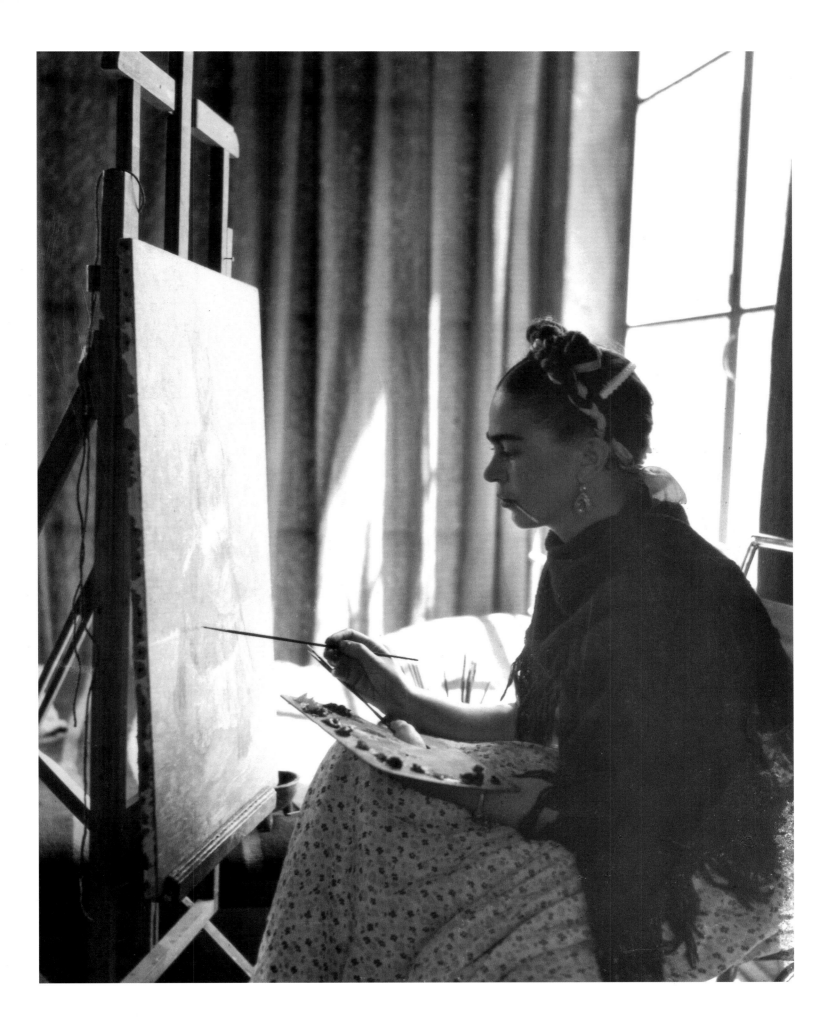

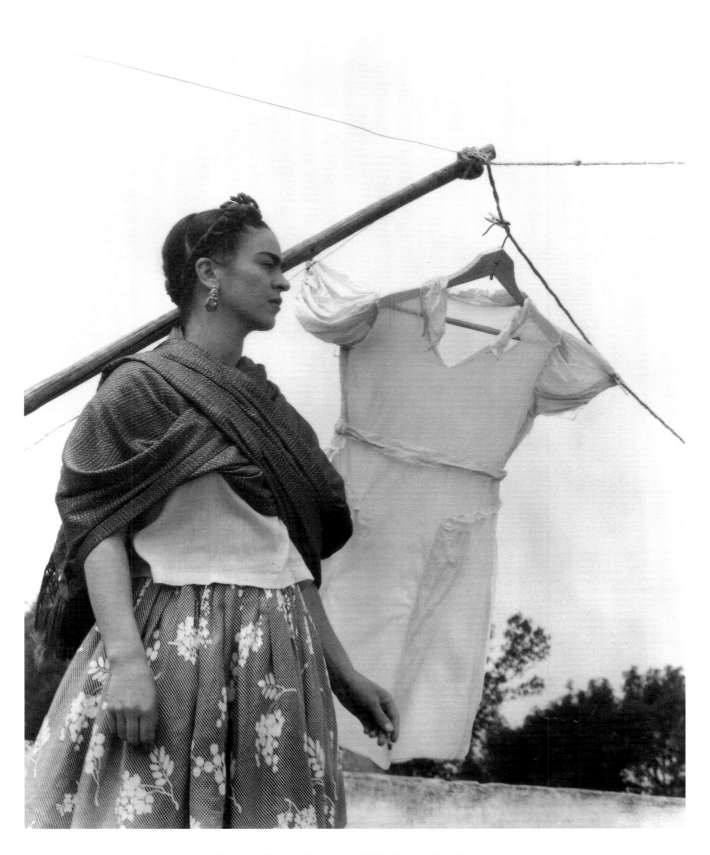

Manuel Alvarez Bravo, ca. 1937, Coyoacán, Mexico

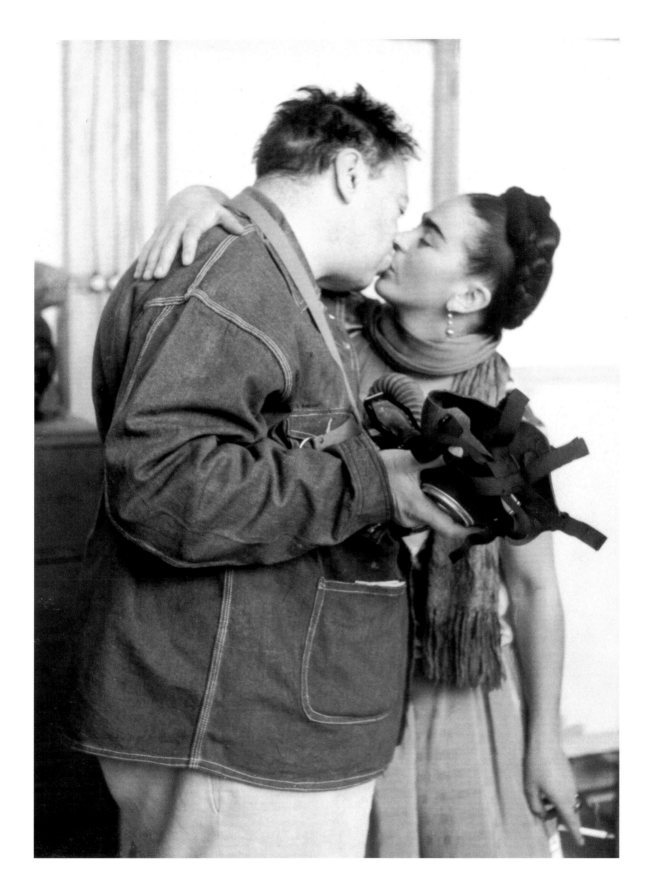

Nickolas Muray, ca. 1940, San Francisco

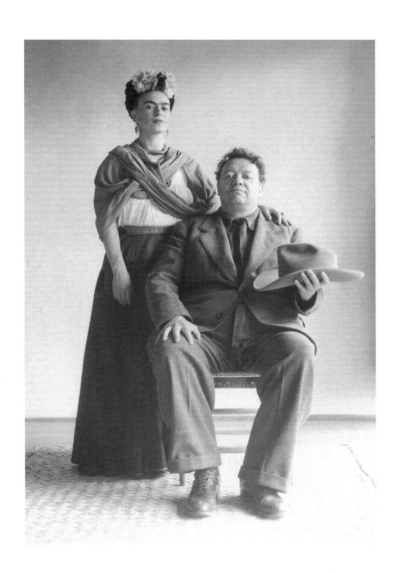

Nickolas Muray, ca. 1940, San Francisco

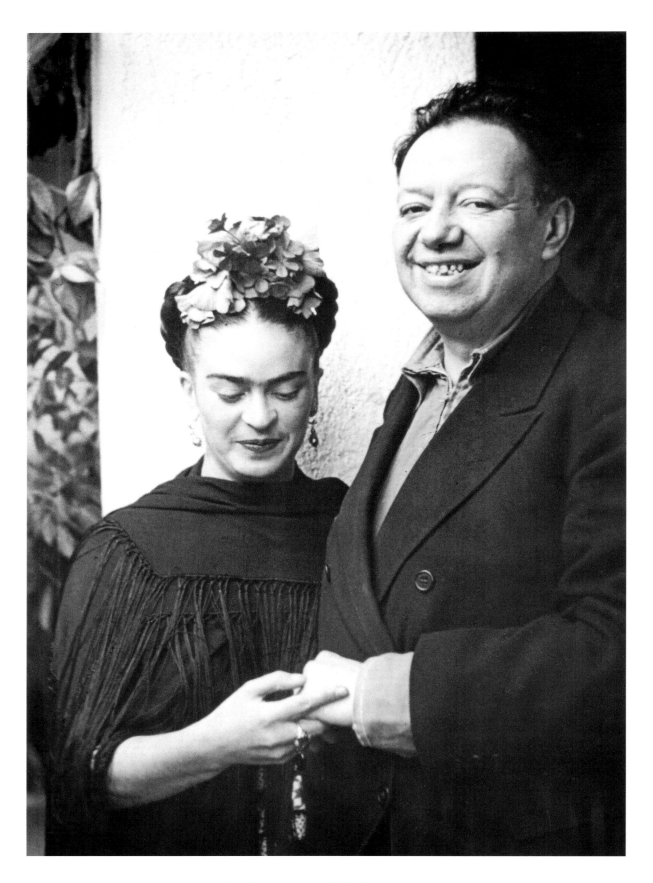

Nickolas Muray, ca. 1940, San Francisco

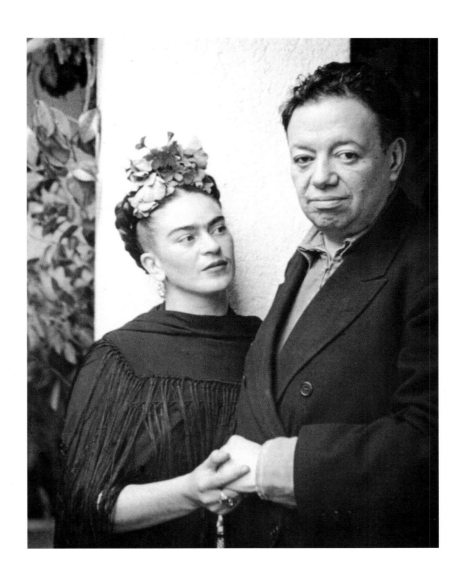

Nickolas Muray, ca. 1940, San Francisco

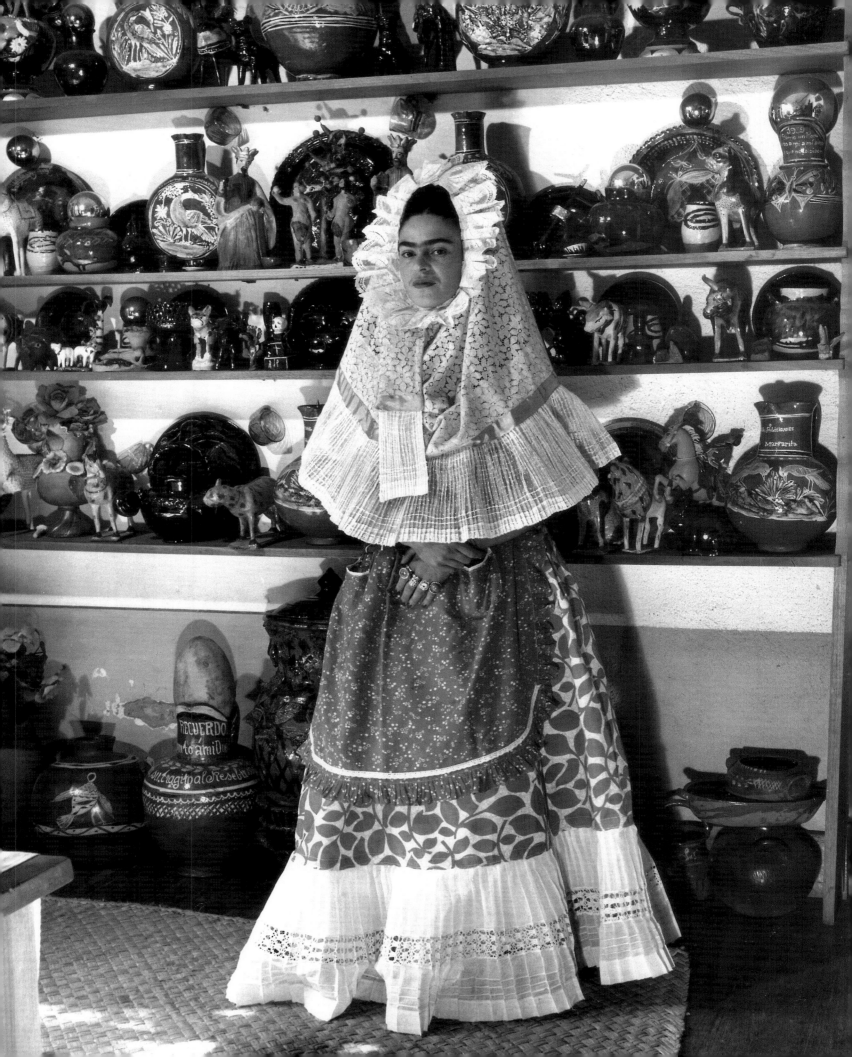

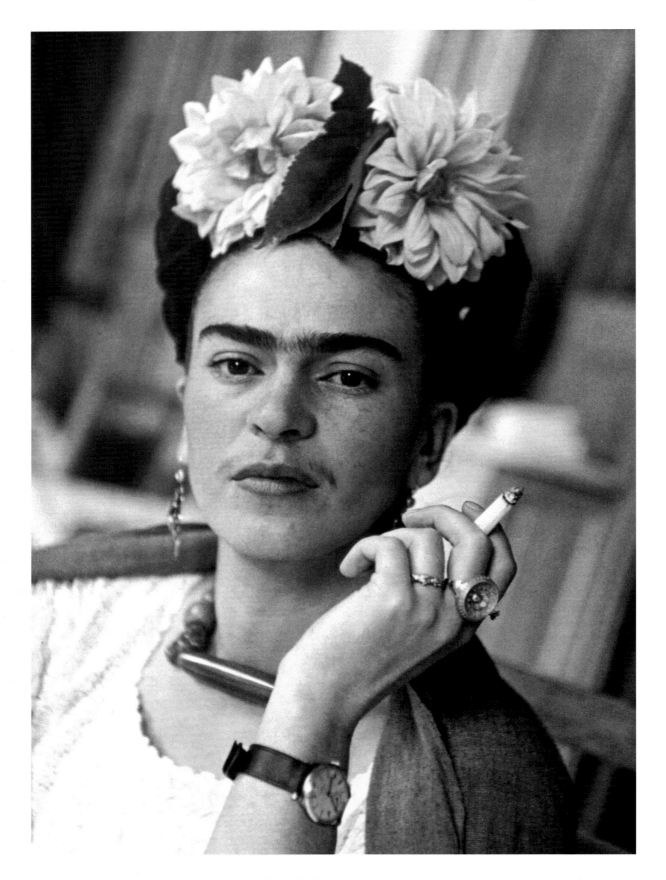

Nickolas Muray, ca. 1940

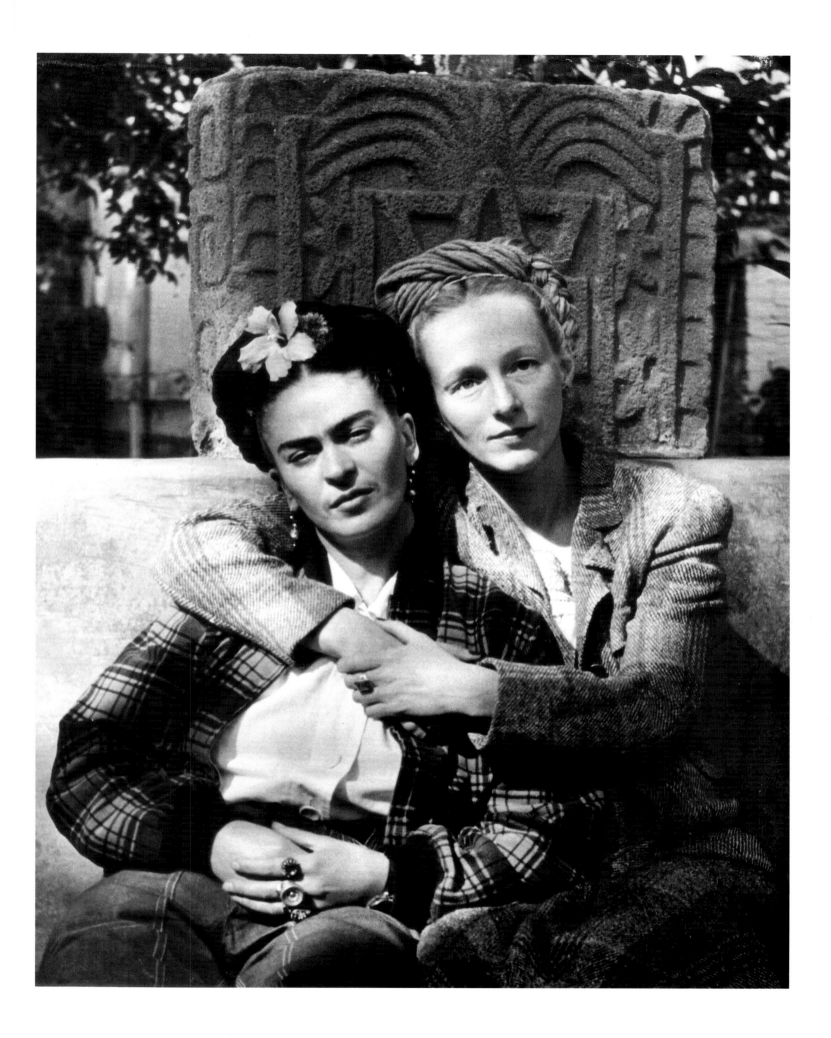

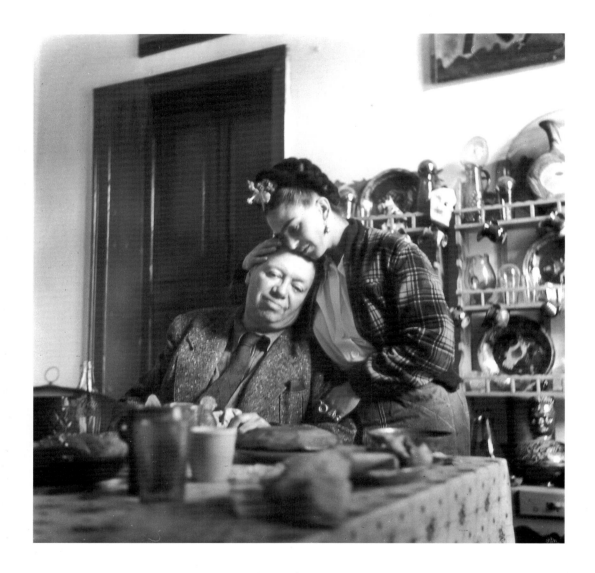

Emmy Lou Packard, 1941, Coyoacán, Mexico

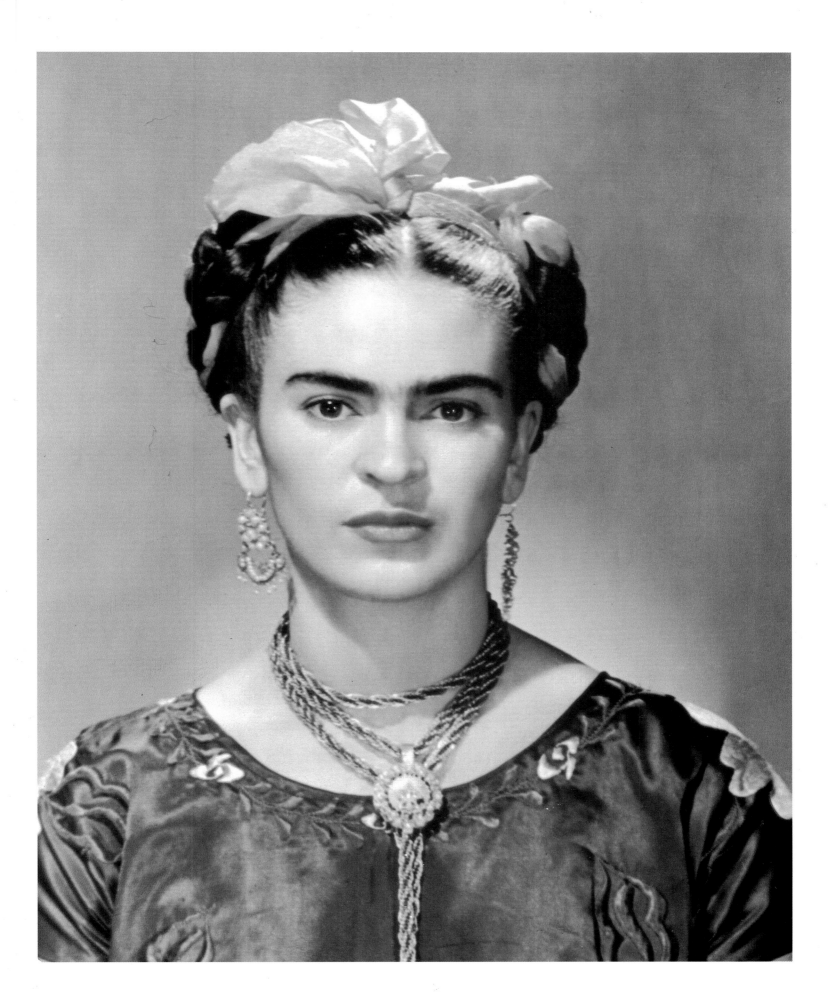

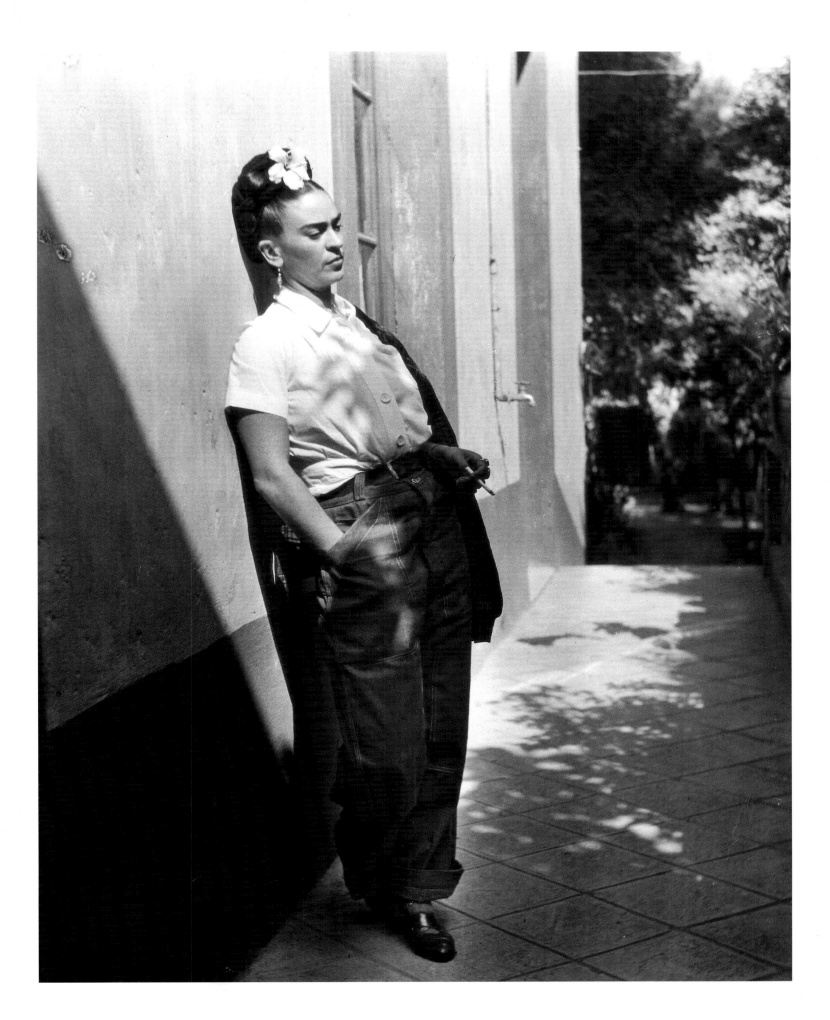

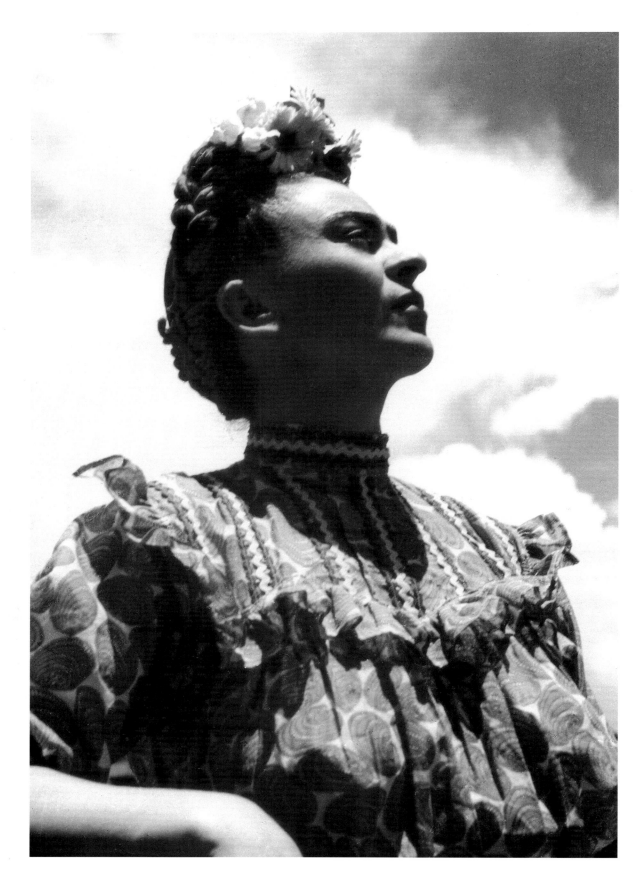

Leo Matiz, 1942, Coyoacán, Mexico

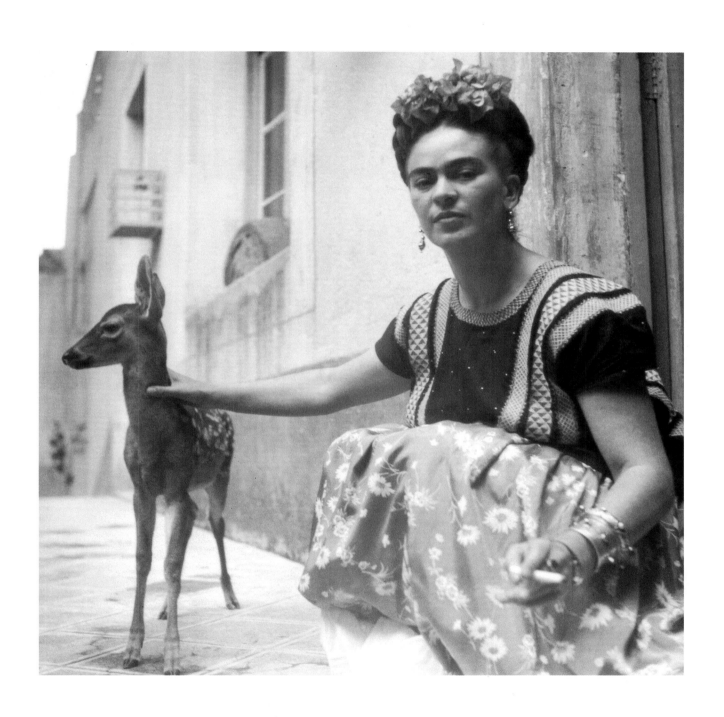

Nickolas Muray, 1940s, Coyoacán, Mexico

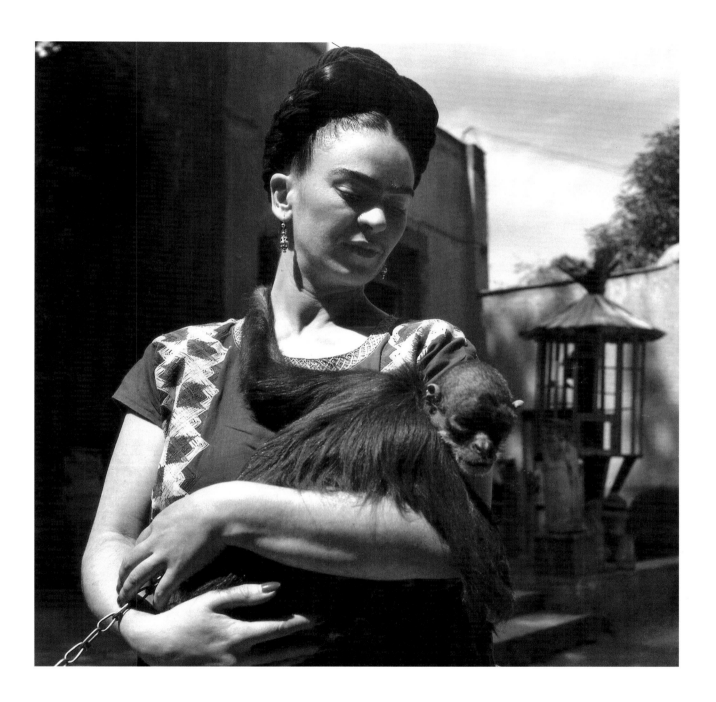

Fritz Henle, 1943, Coyoacán, Mexico

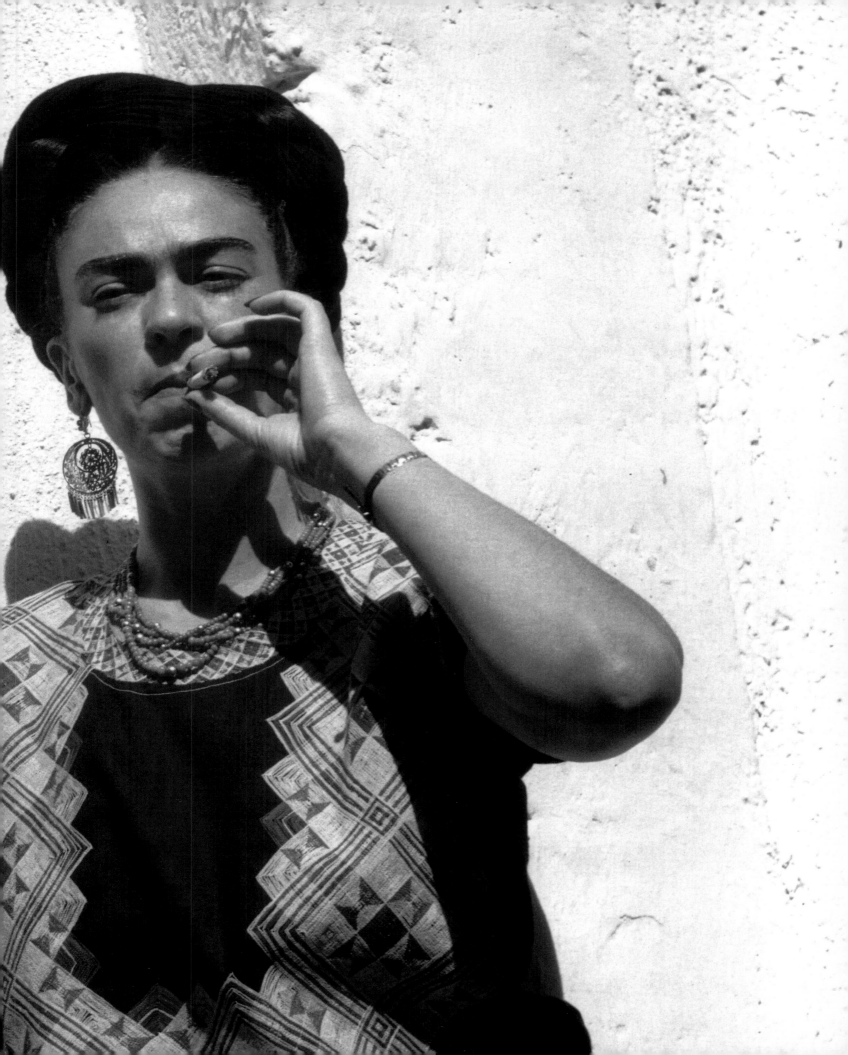

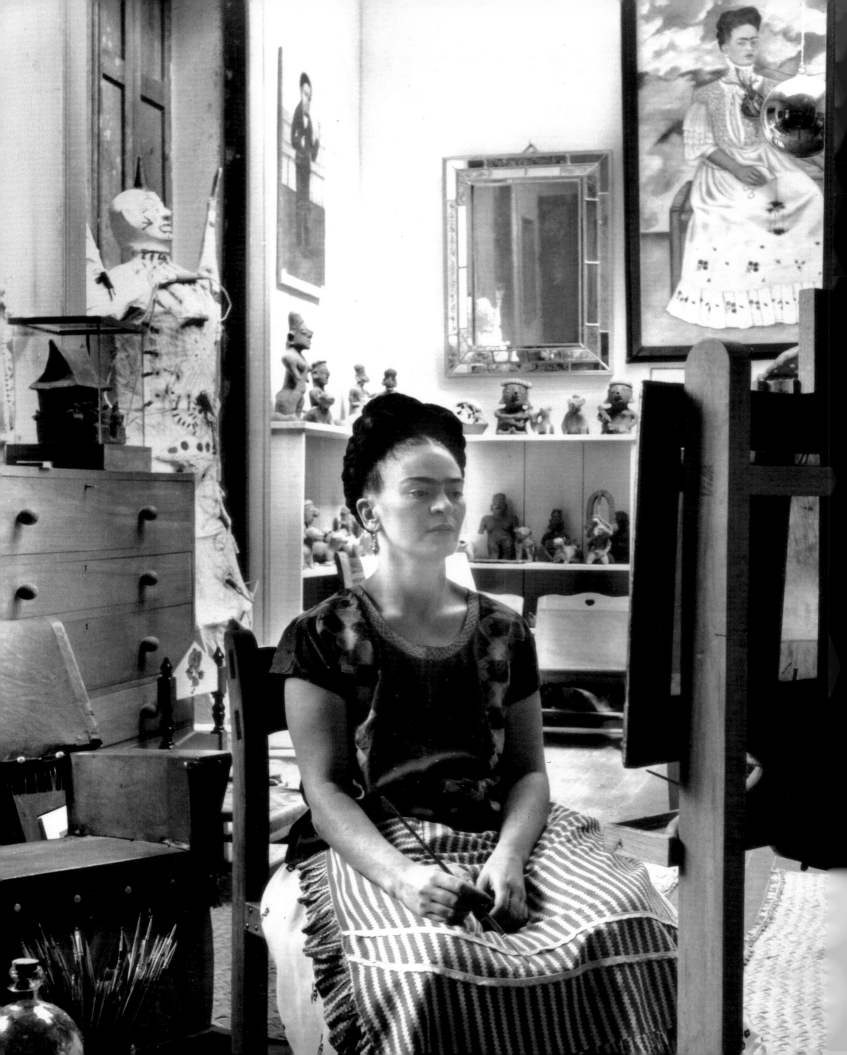

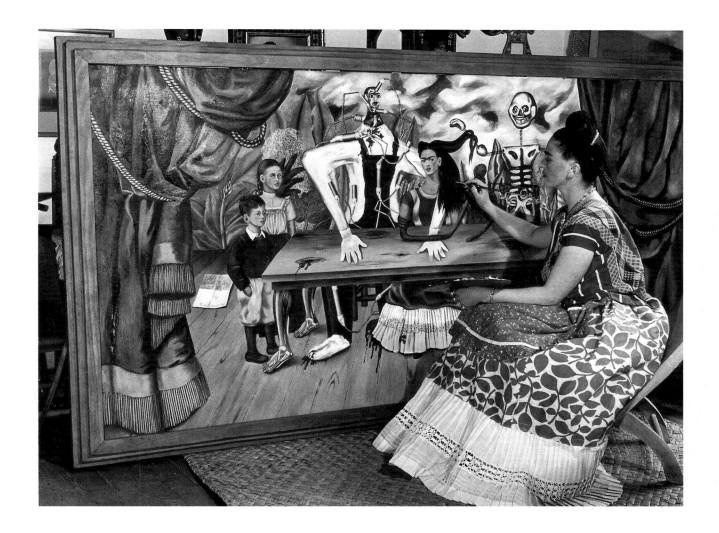

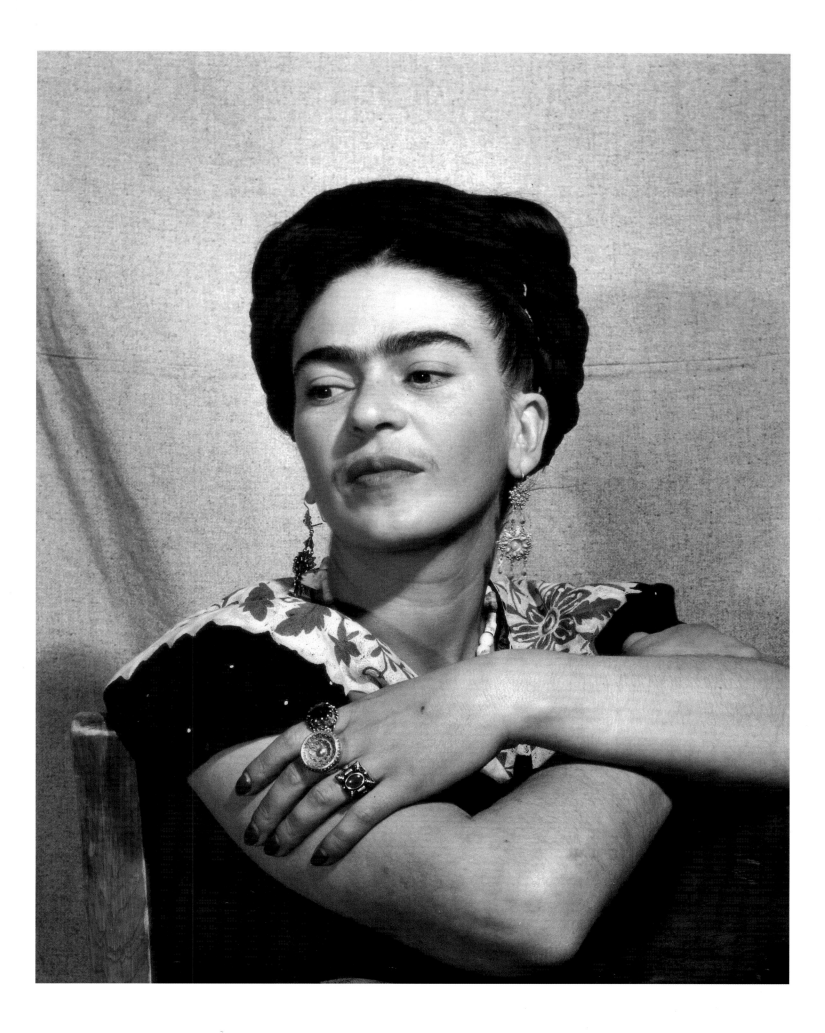

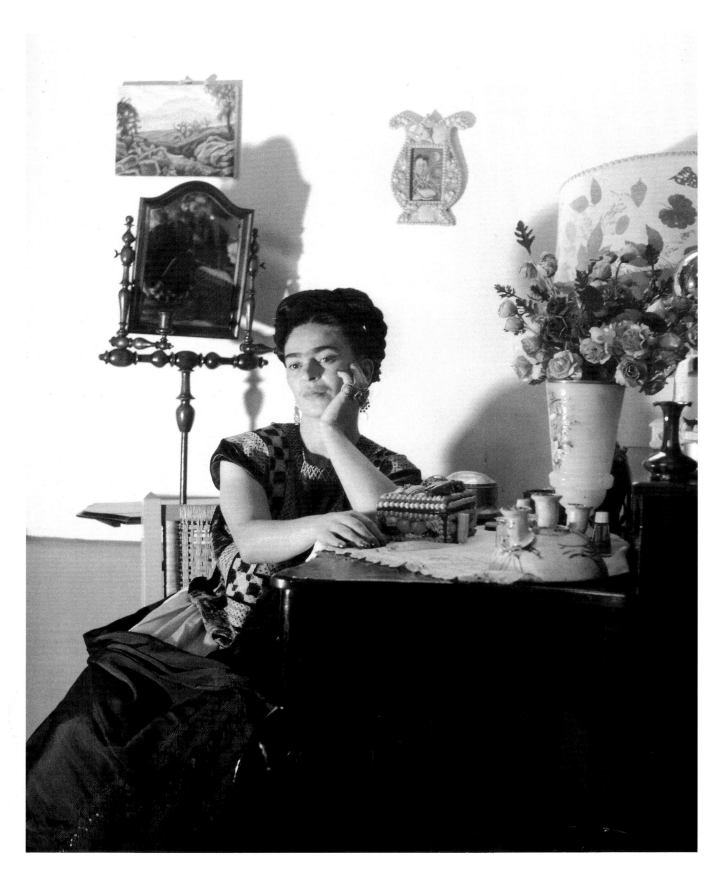

Lola Alvarez Bravo, 1944, Coyoacán, Mexico

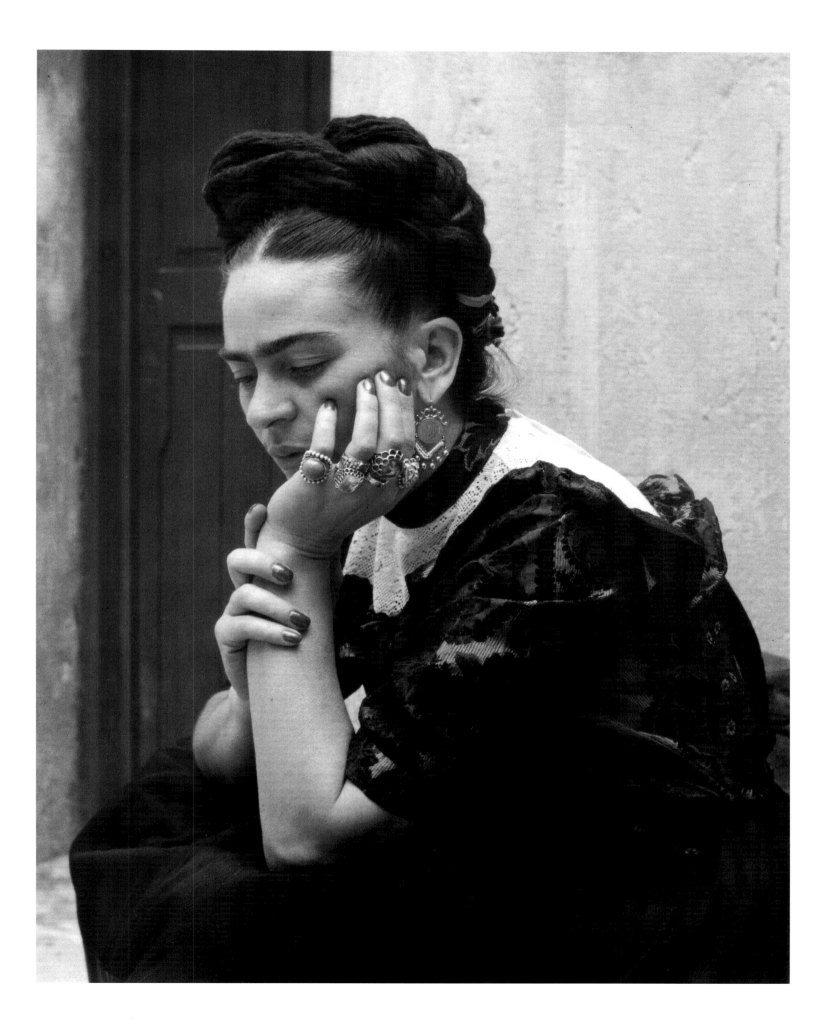

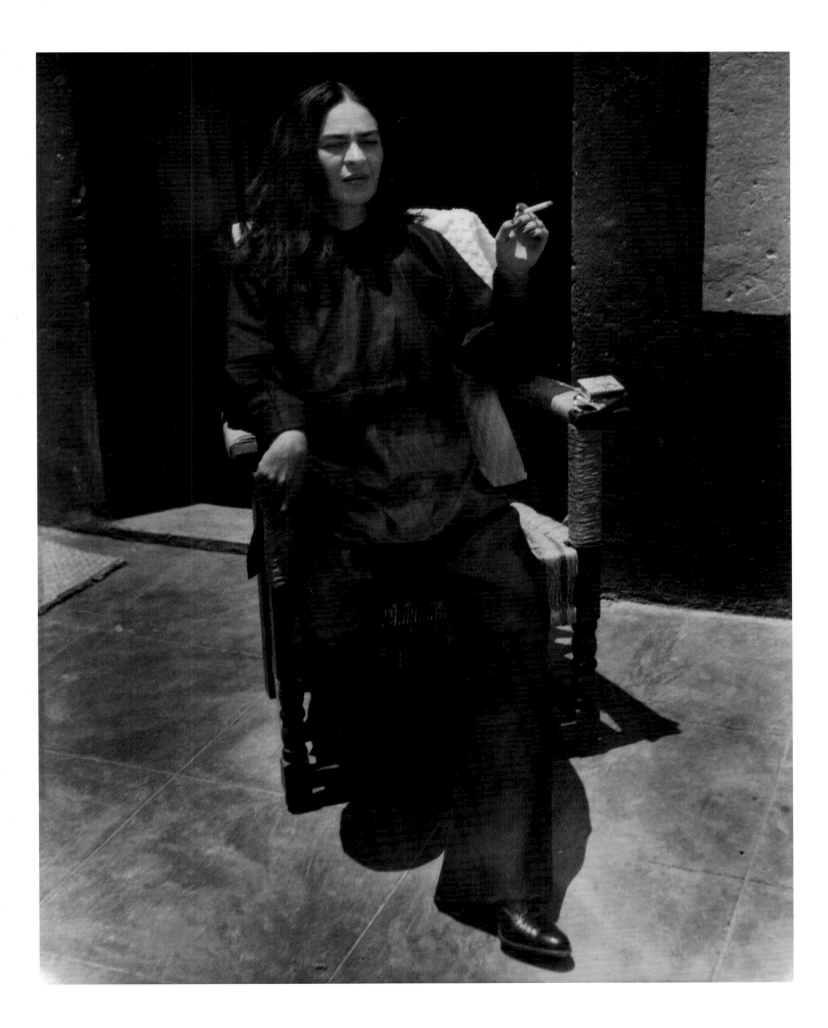

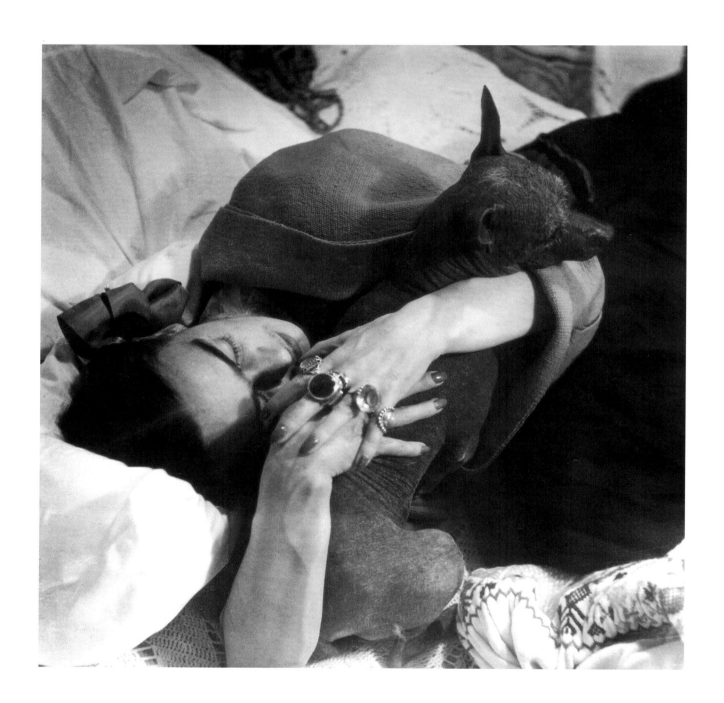

Hector García, 1949, Coyoacán, Mexico

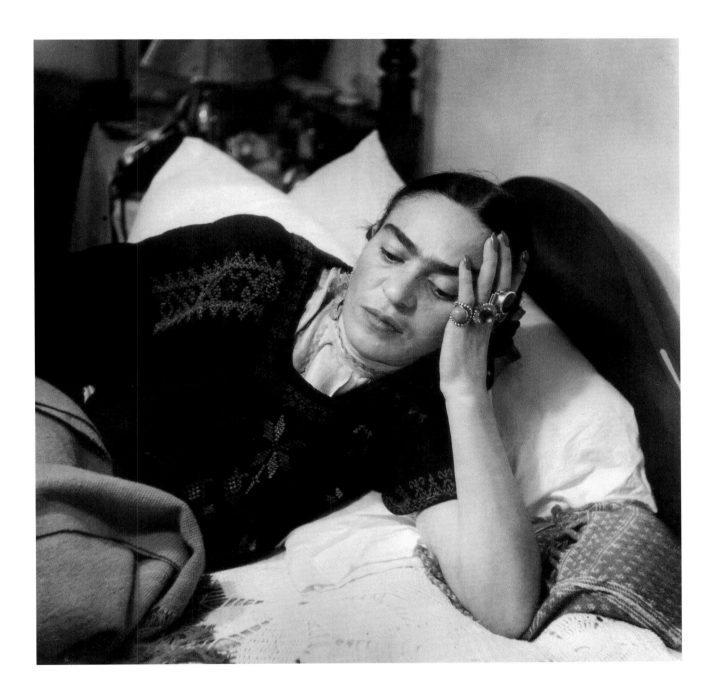

Hector Garcia, 1949, Coyoacán, Mexico

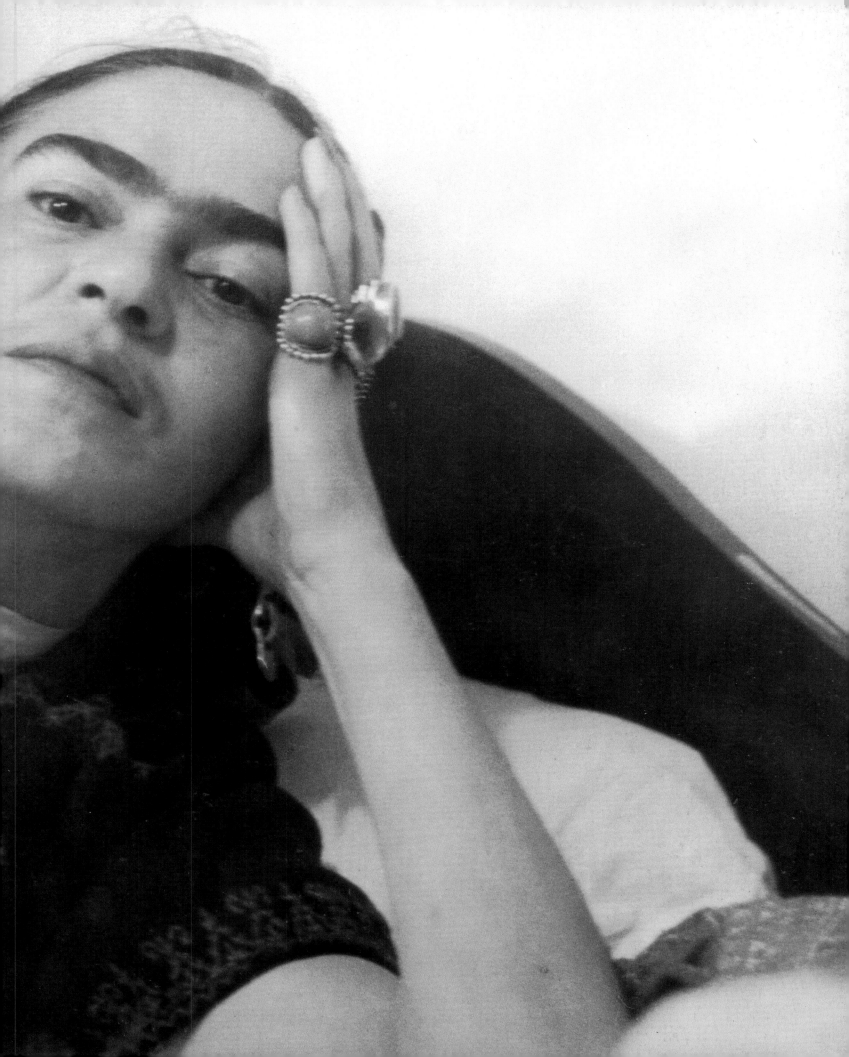

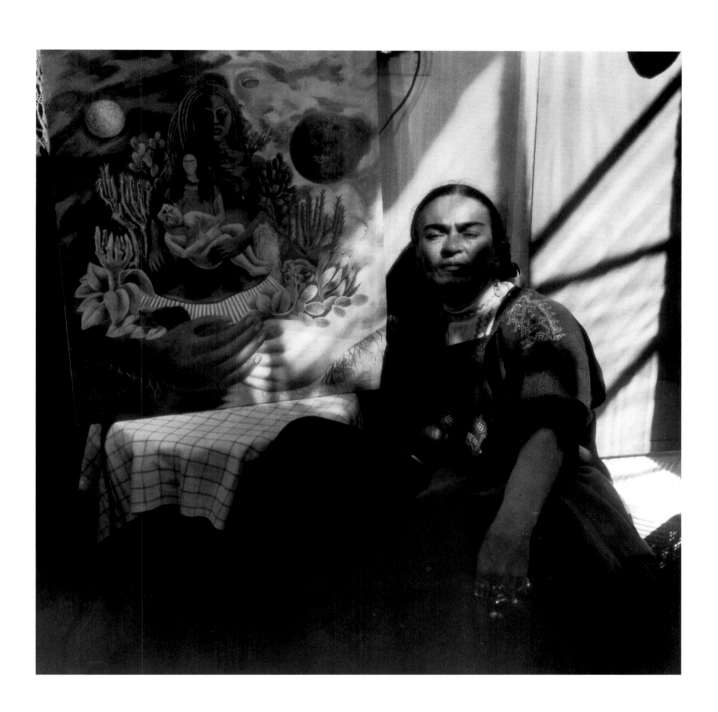

Hector Garcia, 1949, Coyoacán, Mexico

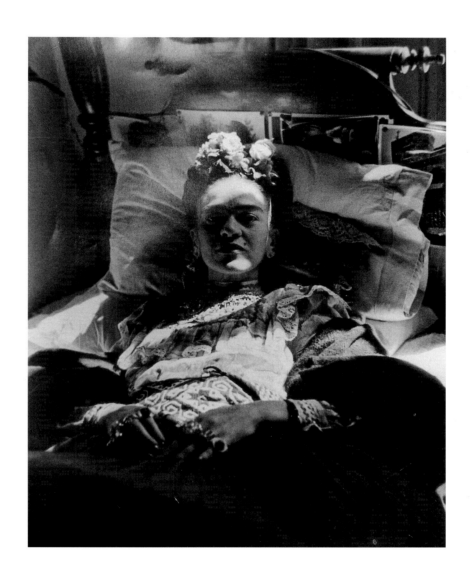

Bernice Kolko, 1952, Coyoacán, Mexico

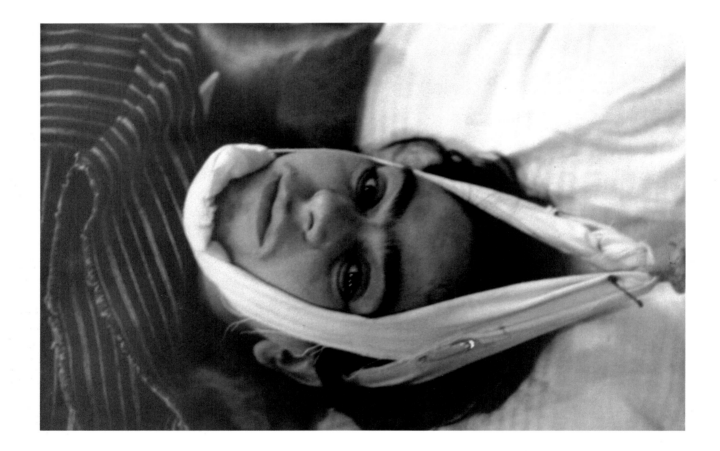

Nickolas Muray, 1940s

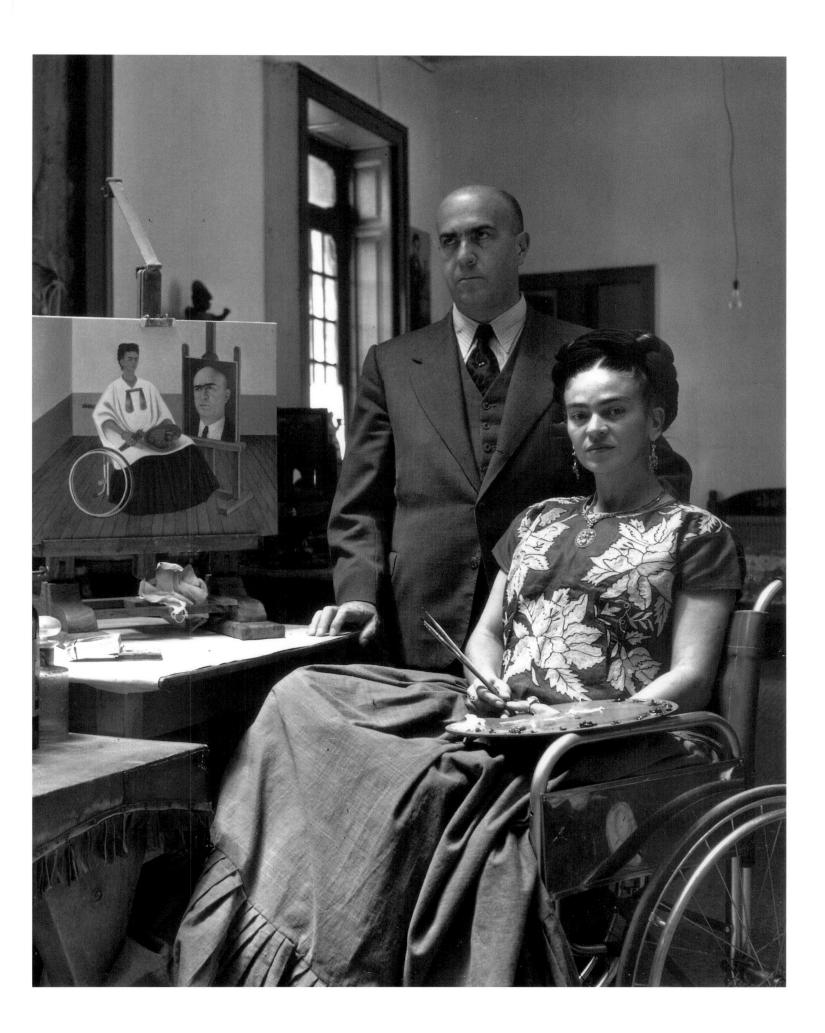

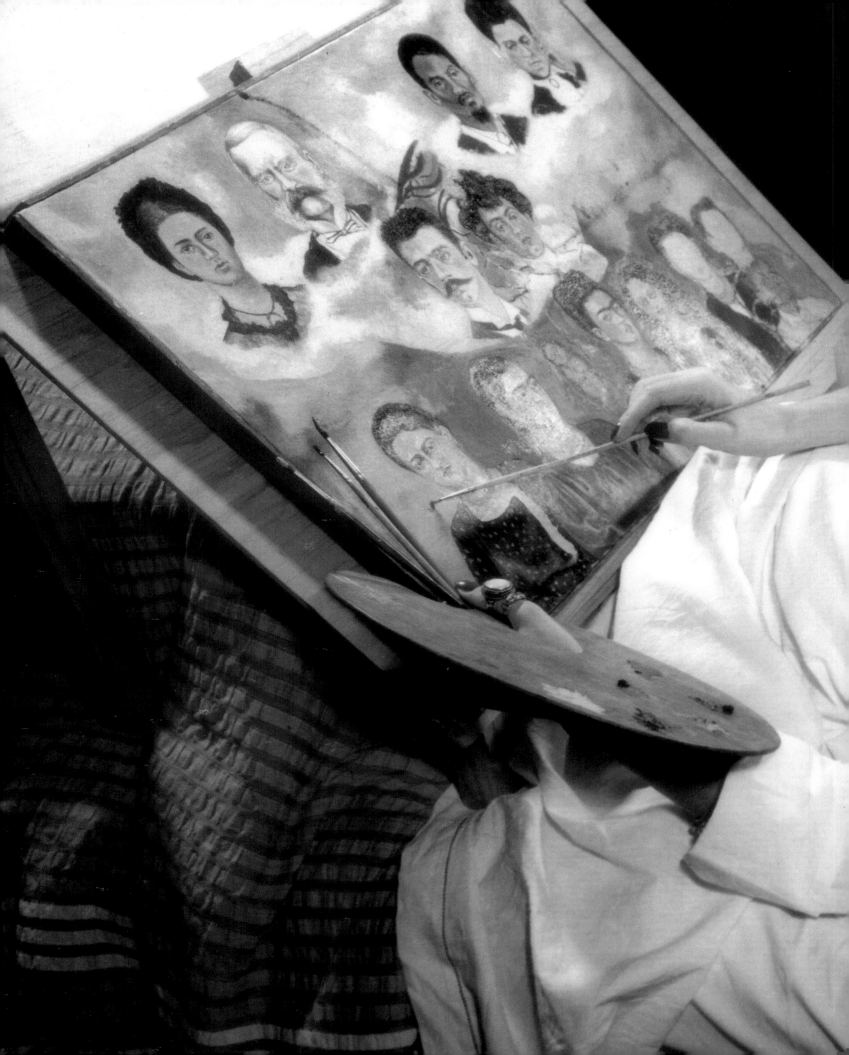

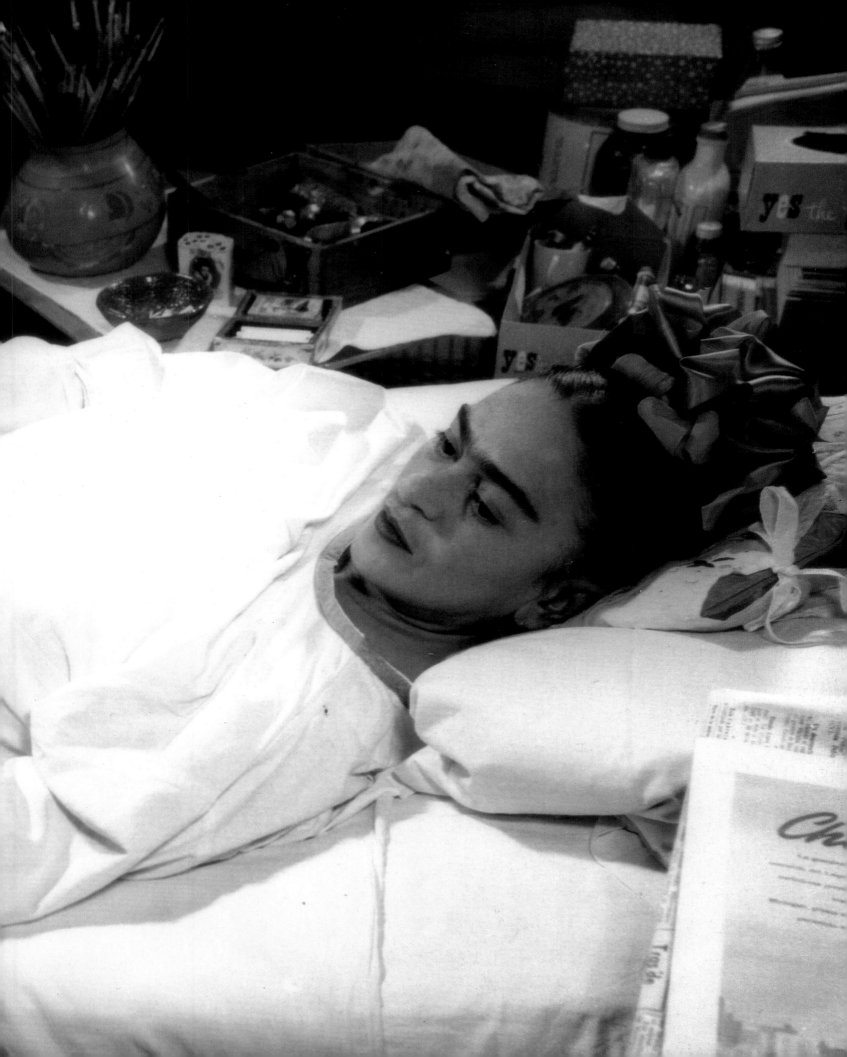

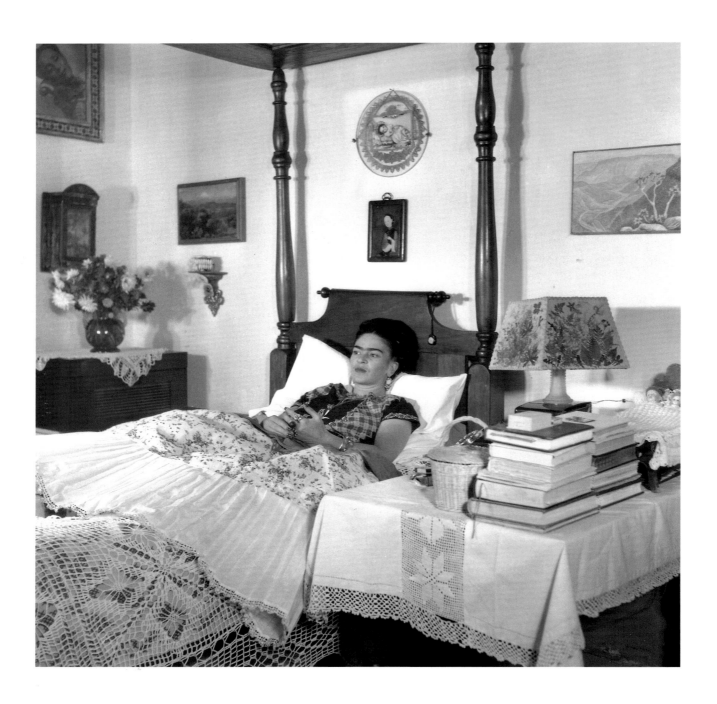

Gisèle Freund, 1952, Coyoacán, Mexico

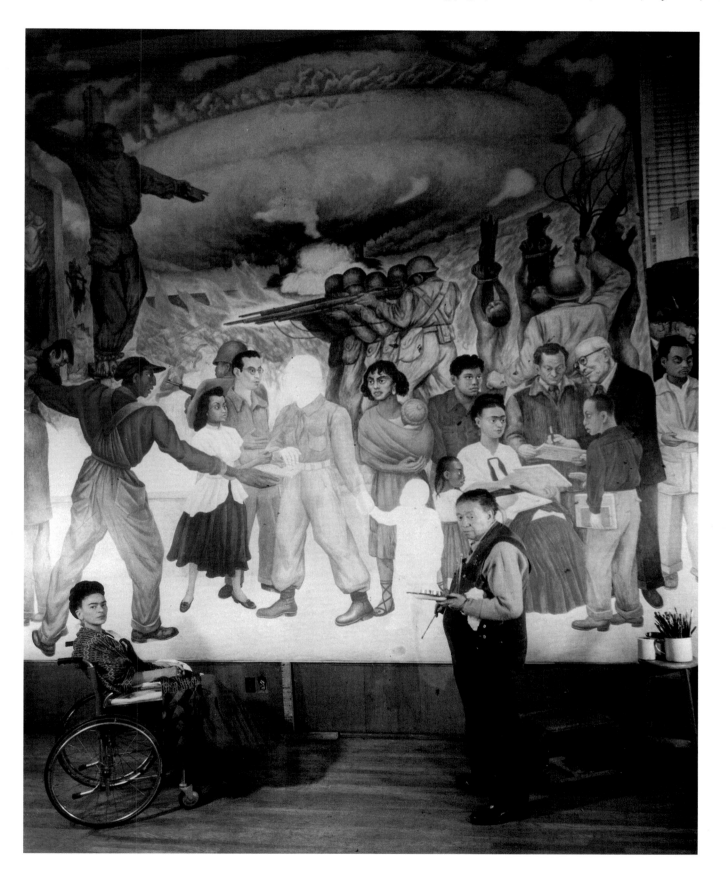

Juan Guzmán, 1952, Mexico City

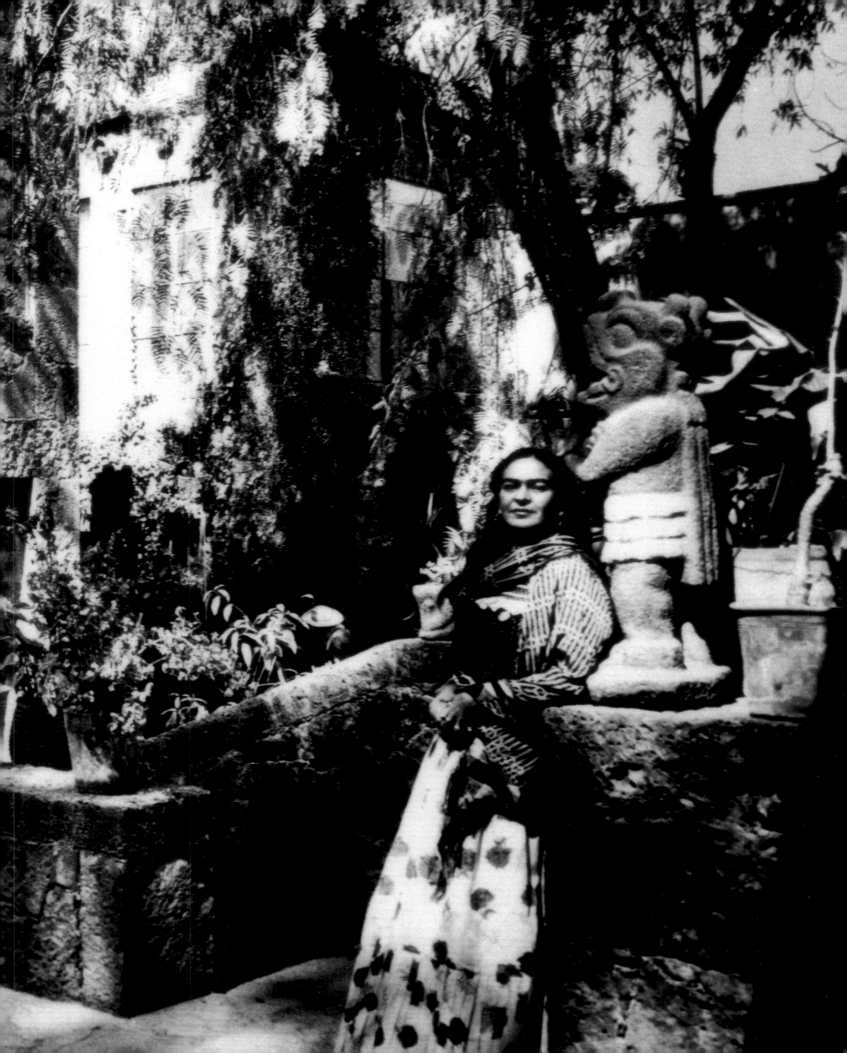

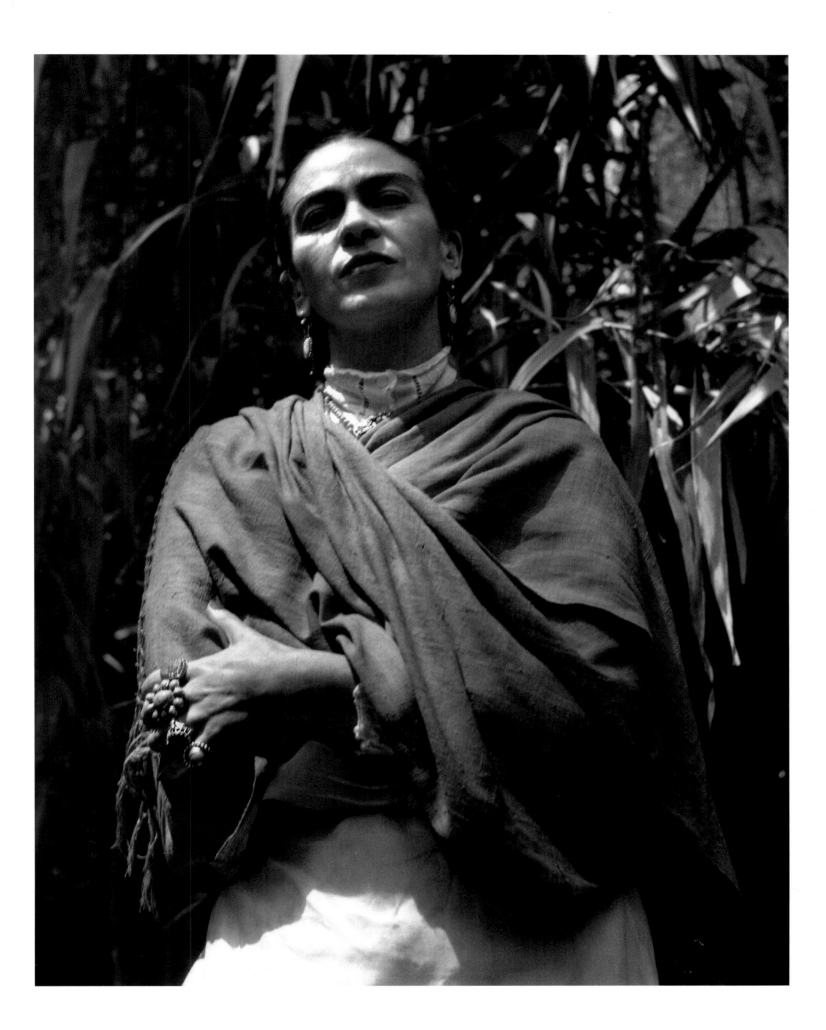

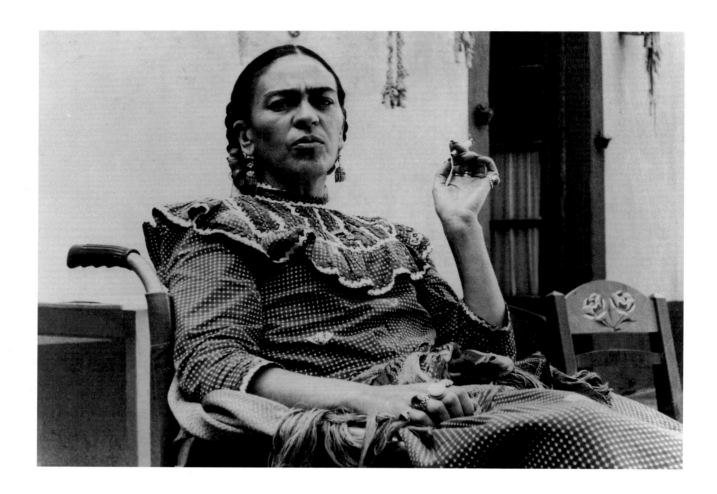

The Brothers Mayo, 1953, Coyoacán, Mexico

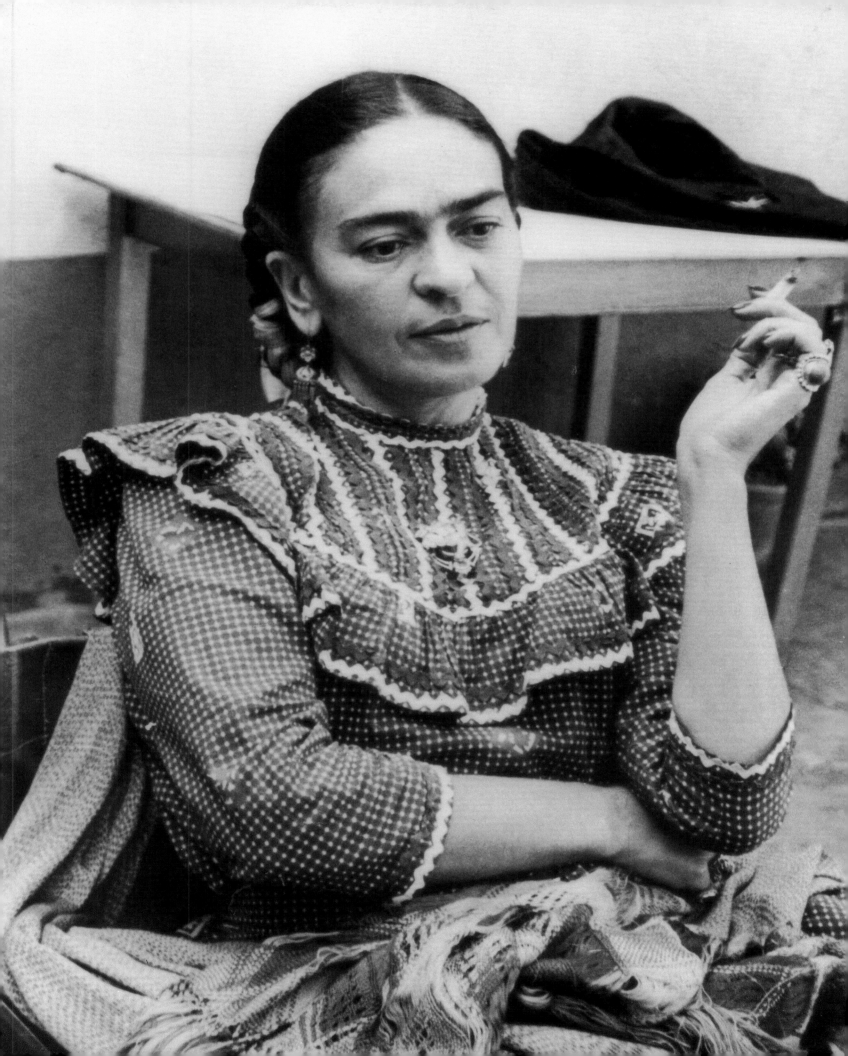

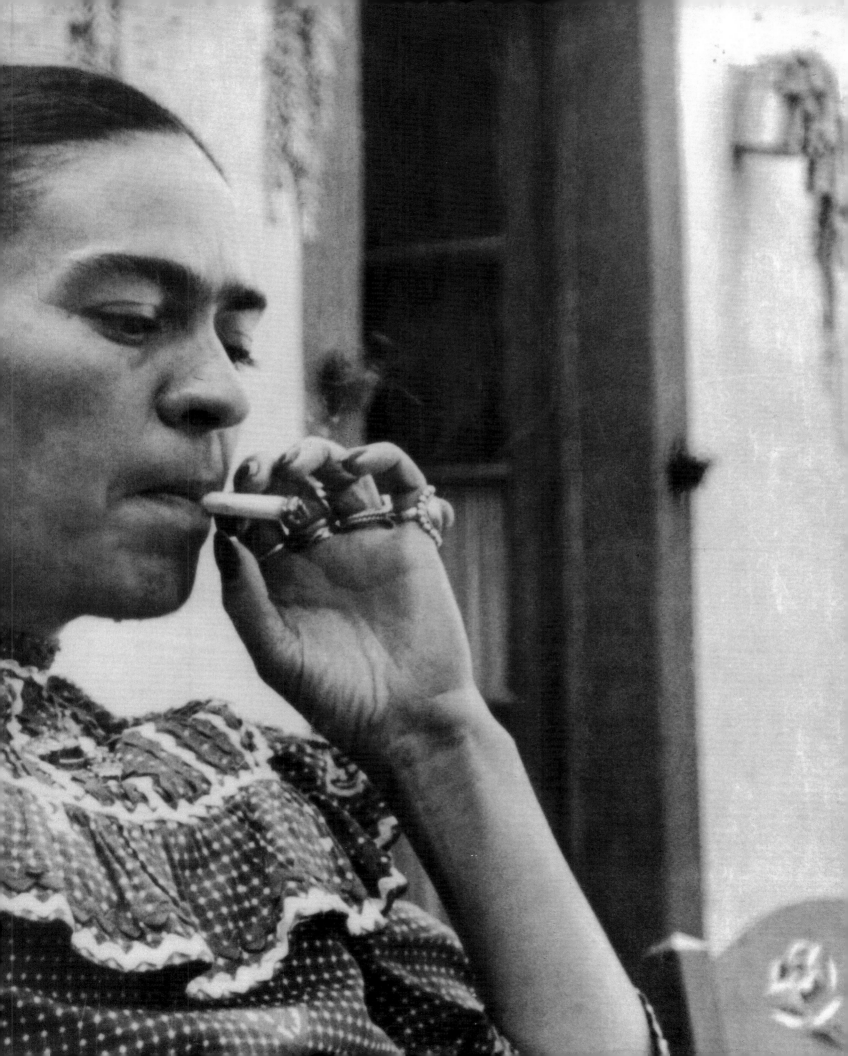

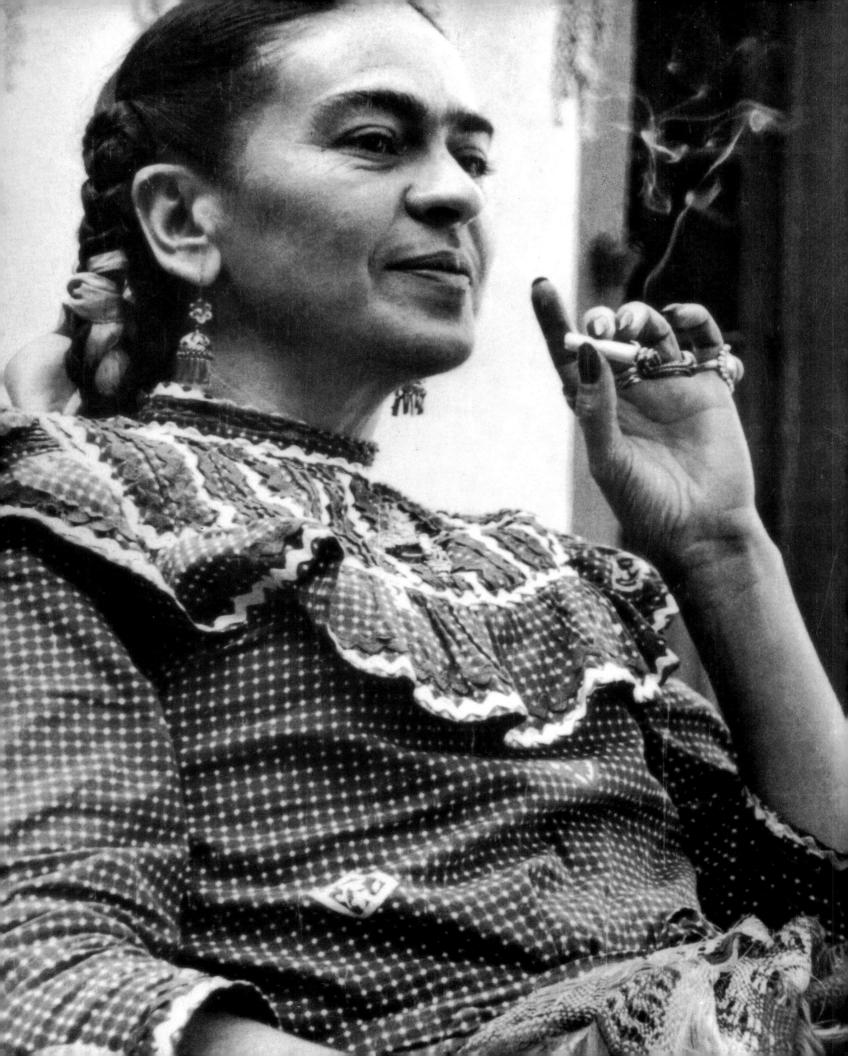

The Brothers Mayo, 1953, Coyoacán, Mexico

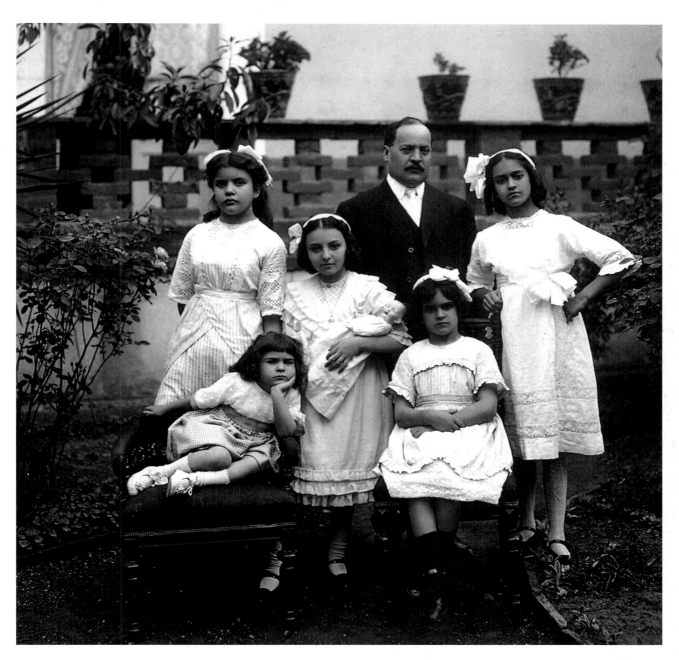

Guillermo Kahlo, 1912, Coyoacán, Mexico. Kahlo (front row, far left), age five, with her family, including her sisters Matilde and Adriana, two cousins, and an uncle.

1907

Born July 6 in Coyoacán, Mexico, third daughter of Matilde Calderón, whose father was a photographer, and Guillermo Kahlo, a German immigrant/photographer.

1910

Three years after her birth the Mexican Revolution breaks out. Later in life, Kahlo claims 1910 was the year of her birth.

1913

Suffers attack of polio, which affects the use of her right leg.

1922

Attends National Preparatory School, one of thirty-five women admitted into a student body of 2,000. Meets Diego Rivera at a party in photographer Tina Modotti's apartment where weekly meetings draw people interested in art and revolution in Mexico. Kahlo subsequently shows her paintings to Rivera while he works on the mural *Creation* in her school's auditorium.

1925

While returning from school on September 17, Kahlo is seriously injured in a streetcar accident when a trolley car collides with the bus on which she is riding. A handrail bar breaks and pierces her from one end of her pelvis to the other. Her injuries and the medical complications that follow require Kahlo to undergo more than thirty-two operations during her lifetime.

1926

Begins to paint while convalescing at home. First paintings include portraits of her sister Adriana and of friends, and her first self-portrait, *Self-Portrait with Velvet Dress*, a gift for her boyfriend Alejandro Gómez Arias.

1928

Affair with Gómez Arias ends. Becomes involved with the Communist party, possibly through the influence of Tina Modotti. Paints *Portrait of*

Cristina, My Sister.

1929

Marries Rivera on August 21. Lives in Cuernavaca, where Rivera is painting a mural in the Palacio de Cortés. Has abortion performed to save her life.

1930

Leaves Mexico for the first time, traveling to San Francisco with Rivera, who is commissioned to paint murals in the San Francisco Stock Exchange Luncheon Club and the California School of Fine Arts (known today as the San Francisco Art Institute). Meets Edward Weston, Imogen Cunningham, and Ansel Adams. Travels to New York and Detroit with Rivera who is planning murals in both cities.

1931

In San Francisco consults with Dr. Leo Eloesser, a famous thoracic surgeon specializing in bone surgery who becomes a lifelong medical adviser and friend. Returns to Mexico in June. Paints *Frida and Diego*, *Portrait of Dr. Eloesser*, and *Luther Burbank*, which is the first of Kahlo's paintings to incorporate surrealist tendencies. Accompanies Rivera to New York for his retrospective exhibition at the Museum of Modern Art in December.

1932

Resides in Detroit while Rivera works on murals about Detroit's automotive industry at the Detroit Institute of Arts. Hospitalized because of severe hemorrhaging and miscarriage. Travels by train to Mexico with friend Lucienne Bloch to see her mother, who is dying of breast cancer. Mother dies. Paints *Henry Ford Hospital*, *The Caesarean*, *My Birth*, and *Self-Portrait on the Border Between Mexico and the United States*.

1933

Returns with Rivera to New York where he begins work on murals in Rockefeller Center, which are later destroyed. Paints *My Dress Hangs*

There or New York. Sails with Rivera from New York to Mexico in December.

1934

Has three operations, including a second abortion. Rivera begins affair with Kahlo's sister, Cristina.

1935

Separates from Rivera. Temporarily takes an apartment in Mexico City. Travels to New York with friends Anita Brenner and Mary Schapiro. Paints *A Few Small Nips*. Reconciles with Rivera when she returns to Mexico from New York. A second foot operation takes six months to heal.

1936

Meets Antonin Artaud during his visit to Mexico. Paints *My Parents, My Grandparents and I* for Dr. Allan Roos and a self-portrait given to Dr. Eloesser that has been lost. Organizes and raises funds for the exiled Spanish Republicans in Mexico. Has affair with Isamu Noguchi. Throughout year, Kahlo suffers intense vertebral pain, has another operation on foot, is treated for an ulcer, and experiences anorexia and general anxiety.

1937

Rivera, ill with kidney and eye trouble, sends Kahlo to receive Leon Trotsky and his wife Natalia Sedova in Tampico harbor. Trotsky and wife move into Kahlo's house Casa Azul for two years. Kahlo begins affair with Trotsky. Completes eight paintings, including *Self-Portrait Dedicated to Leon Trotsky*, *My Nurse and I*, *Fulang-Chang and I*, and *Memory*.

1938

Meets André Breton, French surrealist, during his visit to Mexico. Makes first significant sale of four paintings to Edward G. Robinson, American actor and art collector. First one-person show of paintings is held at the Julian Levy Gallery, New York, for which Breton writes catalog introduction. Begins affair with photographer

Nickolas Muray in New York City. Participates in group show at Mexico's University Gallery. Paints *Cactus Fruits, Xochitl Flower of Life, Izt-cuintli Dog With Me, Four Inhabitants of Mexico City,* and *What the Water Gave Me.* Consults medical specialists because of her foot which develops a serious callous, making it impossible for her to walk at times.

1939
Travels to Paris for the opening of Breton's exhibition "Mexique," which features her paintings. Meets Picasso, Duchamp, and others. The Louvre buys self-portrait, *The Frame.* Contracts kidney infection and is hospitalized in Paris. After her return to Mexico, affair with Muray ends. Paints *The Two Fridas* and *My Nurse and I.* Experiences intense vertebra pains. Dr. Farill prescribes bed rest with twenty kilogram traction weights to stretch vertebra.

1940
Divorces Rivera. Exhibits *The Two Fridas* and *The Wounded Table* in the "International Exhibition of Surrealism" in Mexico City. Travels to San Francisco for medical treatment from Dr. Eloesser, who acts as go-between for Rivera who wants to remarry her. Participates in the "San Francisco Golden Gate International Exhibition" and in "Twenty Centuries of Mexican Art," organized by the Museum of Modern Art in New York. Paints *The Dream, Self-Portrait with Cropped Hair, Self-Portrait (With Thorn Necklace and Hummingbird), Self-Portrait with Monkey,* and *Me and My Parrots.* Remarries Rivera on his fifty-fourth birthday, December 8, in San Francisco.

1941
Father dies. Paints *Self-Portrait with Bonito* and *Self-Portrait with Braid.* Participates in Boston Institute of Contemporary Arts exhibition, "Modern Mexican Painters." Suffers intense exhaustion, spinal pain, loss of weight, and violent pains in extremities. Begins hormonal treatment.

1942
Self-Portrait with Braid is included in "Twentieth-Century Portraits," at the Museum of Modern Art in New York. Begins to paint more still-lifes. Is generally weak and experiencing increased spinal pain.

1943
Begins teaching at the Ministry of Public Education's School of Painting and Sculpture. Exhibits *The Two Fridas, What the Water Gave Me,* and *Self-Portrait (With Thorn Necklace, Monkey, and Cat)* in "Mexican Art Today" at the Philadelphia Museum of Art. Also exhibits in "Women Artists" at Peggy Guggenheim's Art of This Century Gallery in New York. Paints *Roots, Self-Portrait Thinking of Diego,* and *Thinking About Death.* Health continues to deteriorate.

1944
Receives invitation to participate in "Salón de la Flor," an exhibition of flower paintings in Mexico City. Paints a series of portraits, including *Doña Rosita Morillo Sala.* Also paints *Diego and Frida I* and *Diego and Frida II* and *Broken Column.* Receives advice from numerous doctors who prescribe bedrest, a vertebral insert, and the use of corsets and casts to relieve pain.

1945
Paints *Moses, Small Monkey, Without Hope, Self-Portrait with Monkey,* and *The Mask.*

1946
Undergoes spinal surgery in New York City and wears steel cast for eight months. Ignores medical advice prohibiting her from painting; draws while recuperating. After three months pain, exhaustion, and depression return. Paints *The Little Deer,* *Tree of Hope,* and other works that are later exhibited in "Salón del Paisaje," a landscape exhibition in Mexico City.

1947
Self-Portrait as a Tehuana is included in "Forty-five Self-Portraits by Mexican Painters from the XVIII to the XX Centuries" at the National Institute of Fine Arts in Mexico City. Paints *Self-Portrait With Loose Hair.* Has third miscarriage.

1949
Paints *Diego and I* and *The Love Embrace of the Universe, the Earth (Mexico), Diego, Me, and Señor Xolotl,* which is exhibited at the inaugural exhibition of the Salón de la Plástica Mexicana in Mexico City.

1950
Hospitalized for most of the year due to recurring spinal problems caused by infection provoked by spinal insert. Paints *My Family.*

1951
Paints *Self-Portrait with Portrait of Dr. Juan Farill, Portrait of My Father,* and six still lifes.

1952
Continues to paint more still lifes, including an anti-fascist still life in favor of peace.

1953
Kahlo's only one-person exhibition in Mexico, organized by Lola Alvarez Bravo, opens at Galería Arte Contemporáneo in Mexico City in April. Right leg is amputated below the knee due to gangrene in August.

1954
Dies on July 13. Medical certificate states pulmonary embolism as cause of death. Her ashes are contained in a pre-Columbian jar shaped like a headless woman and placed in her home, Casa Azul.

Following pages: Guillermo Kahlo, ca. 1926, Coyoacán, Mexico. Kahlo (center), dressed in men's clothing, with her mother Matilde and sister Cristina.

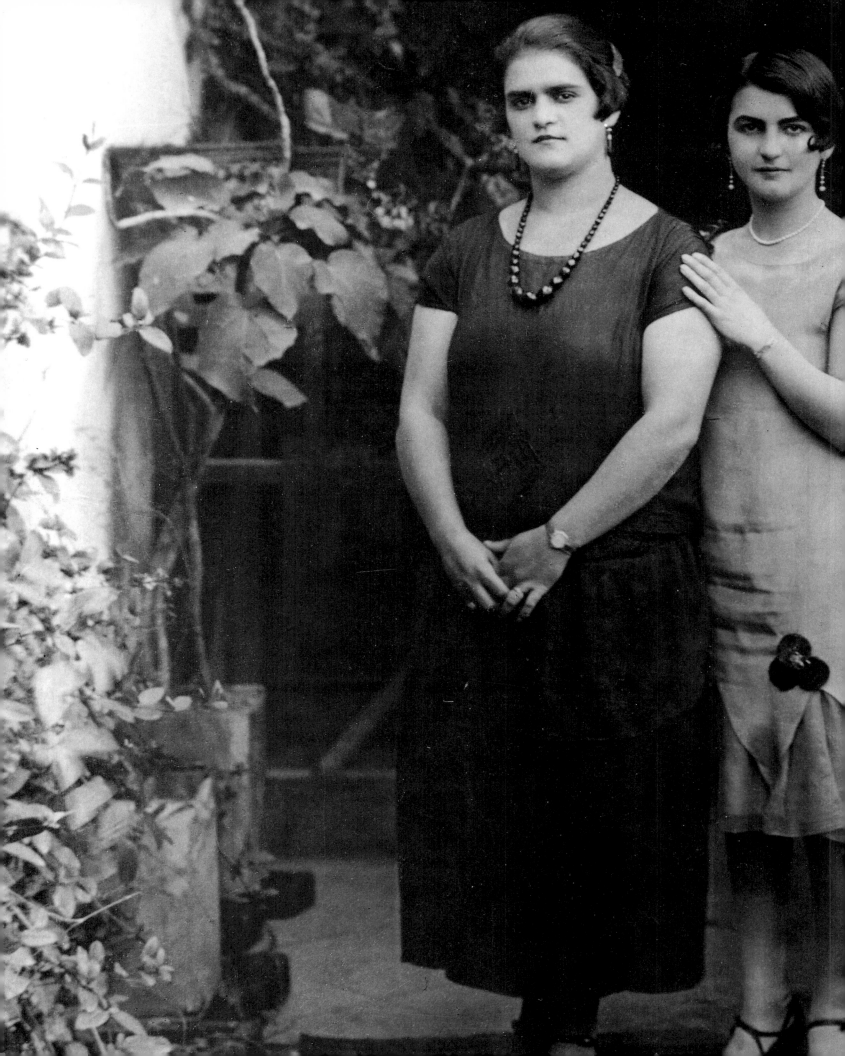

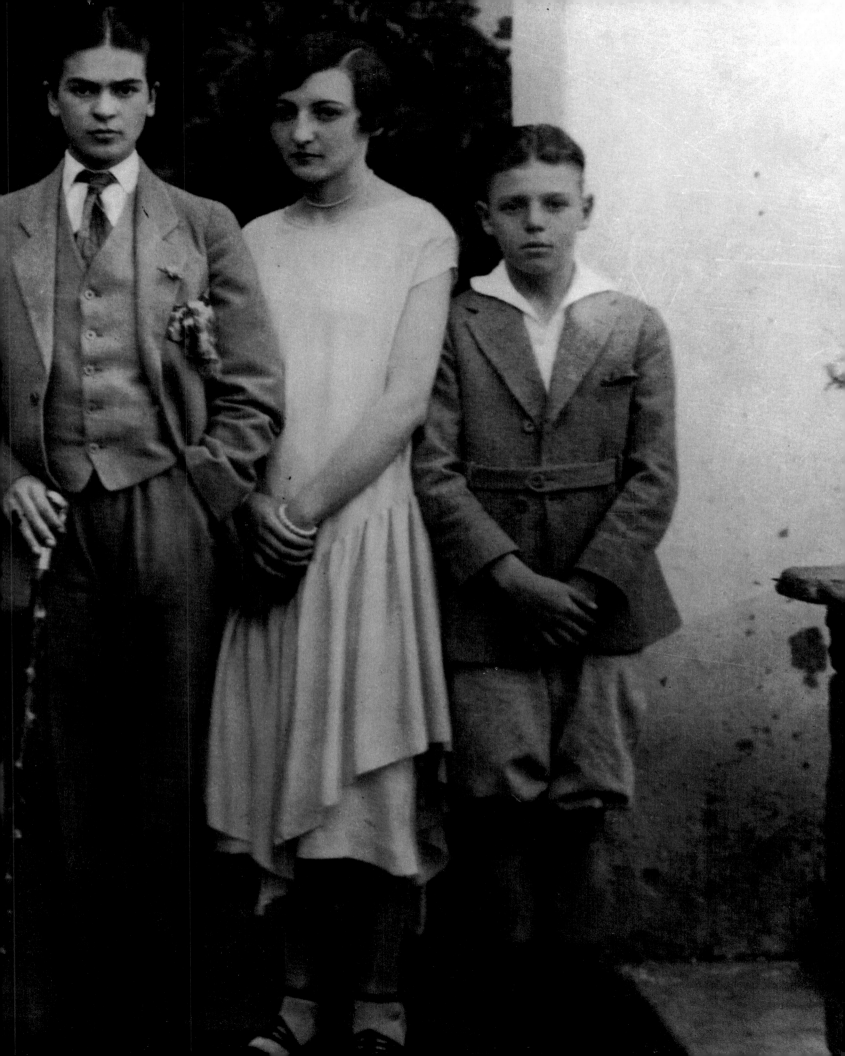

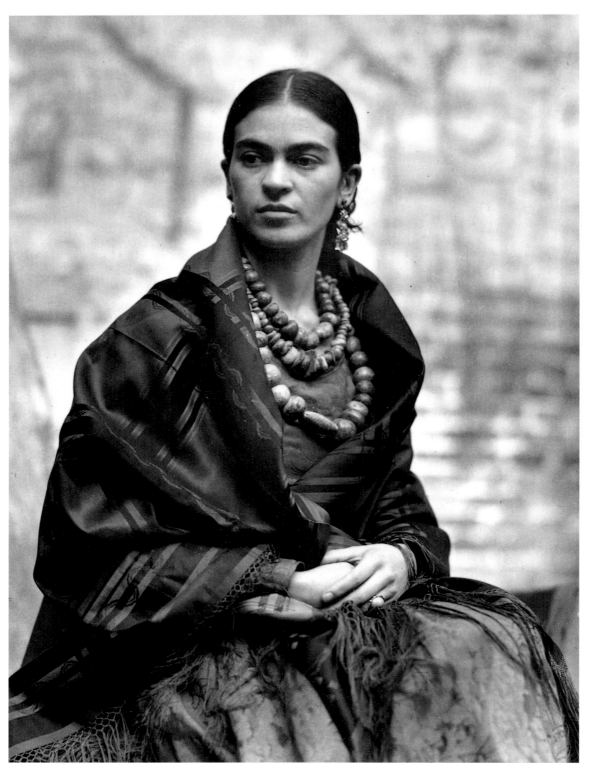

Edward Weston, 1930, San Francisco. Weston photographed Kahlo on her first trip to the United States. *Center for Creative Photography, Arizona Board of Regents.*

THE CAMERA'S SEDUCTRESS

Carla Stellweg

Whenever she could, Frida Kahlo took charge of her life and her history. Born in 1907, Frida changed her birth date to 1910, the year the Mexican Revolution resounded through her country. Her gesture identified her with the political upheaval of the next decade that was destined to return Mexico to the Mexican people. Labor and land reform laws forged a proud, new dignity for the Mexican peasants who had been oppressed by the self-serving dictator Porfirio Díaz.

Frida Kahlo was at the very center of the passion that inspired her country's revolutionary zeal; it was the same passion that shaped her ideas, her art, and her persona. It was in the context of Mexico's revolutionary culture that Frida emerged as a painter, developing her small-scale, intimate self-portraits alongside the aggressively masculine and politically dominating Mexican muralists, including José Clemente Orozco, David Alfaro Siqueiros, and the man she married twice, Diego Rivera.

"I paint my own reality," Frida declared. Although her art was not physically monumental, it was intense in its autobiographical content and profound in its understanding of her psychology and her native culture.

Frida Kahlo invented and recreated herself throughout her life with intelligence and verve. She fascinated people with her magnetism and intelligence and attracted many photographers who took on the challenge of picturing her dramatic spirit. Each tried to unravel Frida's ambiguity, her passion, her charm, and her seductive style. Some were her friends and lovers; others were acquaintances or professional photographers assigned to photograph her for magazines and newspapers. For all of them, Frida, with an innate sense of what she wanted to look like, molded her expression and positioned her body, angling her head and using her eyes to conjure a presence that left no one untouched. Her natural *mestiza* beauty—high cheekbones, pronounced jawline, and intense dark eyes framed by thick, curved eyebrows—encouraged the transformation of her face into an icon. What each photographer rendered is a woman whose identity cannot be mistaken; a person truthful about herself, unafraid to show what life has leveled at her, and proud of what she has made of herself.

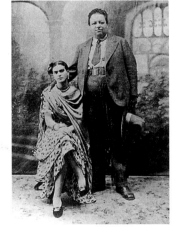

Victor Reyes and Family, 1929, Coyoacán, Mexico. Kahlo and Rivera two days after their first marriage in 1929.

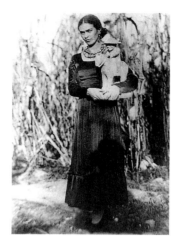
Guillermo Davila, n.d.

In nearly every picture Frida gives a mysterious, sensuous semi-smile. One wonders why we never see the fun-loving, raucous Kahlo laughing with abandon that her friends described. Perhaps no smile lightened her face before the camera because she was self-conscious about her bad teeth, which she had incised with gold and capped with diamonds for special occasions. Overcoming handicaps was an aspect of Kahlo's capacity to sublimate pain—to turn weakness into strength—and to become an active participant in the cultural, historical, and political events of her time.

Frida Kahlo was the daughter and granddaughter of photographers. Guillermo Kahlo, by Kahlo's account, took up photography at the suggestion of his second wife, Matilde Calderón, Frida's mother. Matilde's father had been a photographer, and it was with his equipment that Guillermo began to photograph. Early in his career Guillermo traveled around Mexico photographing indigenous Colonial architecture. From 1904 to 1908 he was commissioned by the government to record the country's architectural heritage. He produced 900 glass plate negatives that illustrated a series of large-format deluxe publications celebrating the centennial of Mexican independence. His accomplishments earned him the title of "first official photographer of Mexico's cultural patrimony."

In his studio he introduced his favorite daughter to photographic equipment, and from time to time Frida would assist him in retouching his glass plates. She and her family sat for official family portraits, even though Guillermo rarely photographed people, because, as he said, he "did not wish to improve what God had made ugly." At the age of five, in a photograph taken by her father (page 99), Frida strikes a seductive pose, resting her round face with its dimpled chin on her chubby arm. Mischievously she looks out at the photographer.

Frida described her childhood in her diary, "My childhood was marvelous because, although my father was a sick man (suffering from epilepsy), he was an immense example to me of tenderness, of work and, above all, of understanding for my problems." In 1952, shortly before her death, Frida used a photograph of her father in one of her paintings, *Portrait of Don Guillermo Kahlo*, as an homage to him. She placed his camera next to him, a third, all-seeing eye. Guillermo looks melancholically off to the side.

As she grew older, photography was a popular art that Kahlo treasured. She loved the imagination and craft of the street photographers who, using different backdrops, set up shop next to churches or in the parks of Mexico City. Her house was filled with images. On the headboard of her bed and on her walls she pinned pictures of her family, her friends, children she loved, the Mexican Revolution, and famous people who fascinated her, among them Marx, Engels, Lenin, Einstein, Freud, and Mao Tse-tung. She also displayed pictures of herself by the photographers who sought her out.

From childhood on, Frida collected dolls, including papier-mâché *Judas* and *calaveras* figures that she dressed up. She owned over 500 *retablos*, small, traditional tin paintings made to thank a patron saint for a recovery from illness, for surviving an accident, or as a gift for a miracle invoked. Images and objects were a rich source of inspiration for her, and are evidence of her native aesthetic preferences.

In Frida's art one sees the extent to which she incorporated popular images. Her paintings often draw

on existing photographs, including *Memory*, *My Dress Hangs There or New York*, and *Moses*. Her attention to detail, her tiny brush strokes, the colors she chose, and even the formality of her small-scale works can be credited to her appreciation of, and involvement with, photography and popular art.

It was the painful circumstances of her life, however, that infused her art with its spirit and its meaning. When Frida was six years old, she contracted a mild case of polio that left her right leg less developed than her left. She compensated for the deformity by becoming a fine athlete. In her black bloomers she played soccer, boxed, skated, and became an excellent swimmer. Her childhood friend, Aurora Reyes recalled, "When she walked, Frida made little jumps so that she seemed to float like a bird in flight."

In 1925 when she was eighteen years old, Kahlo's spine, leg, and foot were badly broken in a grotesque streetcar accident by an iron handrail bar that pierced her body. During her lifetime she would have more than thirty-two operations to alleviate the pain from the consequences of the accident: she also tried to lessen the pain with medication, alcohol, or other drugs.

In a photograph taken by her father the year following her accident, Frida is pictured with her mother, sister Cristina, and other family members (pages 102–103). She wears a three-piece man's suit, a radical costume for a woman in the male-dominated Mexican society with strict Catholic morals. Kahlo is relaxed, one hand casually in her pants pocket. Her eyes question and seduce the photographer who is none other than her father. Clearly, Frida consciously decided she was going to look different from the rest of her family who pose conventionally. Aloof and prepossessed, she seems ready for whatever might come her way.

Even before the accident Frida dressed in blue overalls, ties, and black boots. Her cropped, thick hair and the gaze of her dark, mocking eyes provoked the mothers of fellow students to call out, "*Que niña tan fea!*" (What an ugly girl)! Demonstrating an attitude of irreverence, she cultivated the company of male *cuates* (pals) to that of the girls she called *cursi* (tacky and gossipy).

During the years she convalesced from 1925 to 1927, photographs of Kahlo do not reveal the intense transformation of her personality that was taking place. In one of her letters to her boyfriend Alejandro Gómez Arias, she described how she was shaping a vision of herself:

"Why do you study so? What secret are you looking for? Life will reveal it to you soon. I already know it all, without reading or writing. A little while ago, not much more than a few days ago, I was a child who went about in a world of colors, of hard and tangible forms. Everything was mysterious and something was hidden, guessing what it was a game to me. If you knew how terrible it is to know suddenly, as if a bolt of lightening elucidated the earth. Now I live in a painful planet, transparent as ice; but it is as if I had learned everything in seconds. I became old in instants and everything today is bland and lucid. I know that nothing lies behind, if there were something I would see it."

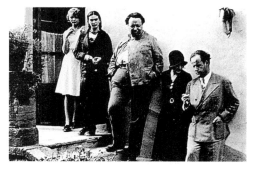

Photographer unknown, 1931. Kahlo and Rivera with Soviet filmmaker Sergei Eisenstein and collector Francis Flynn Paine.

Following pages: Photographer unknown, 1929. Marching with Syndicate of Technical Workers, Painters, and Sculptors.

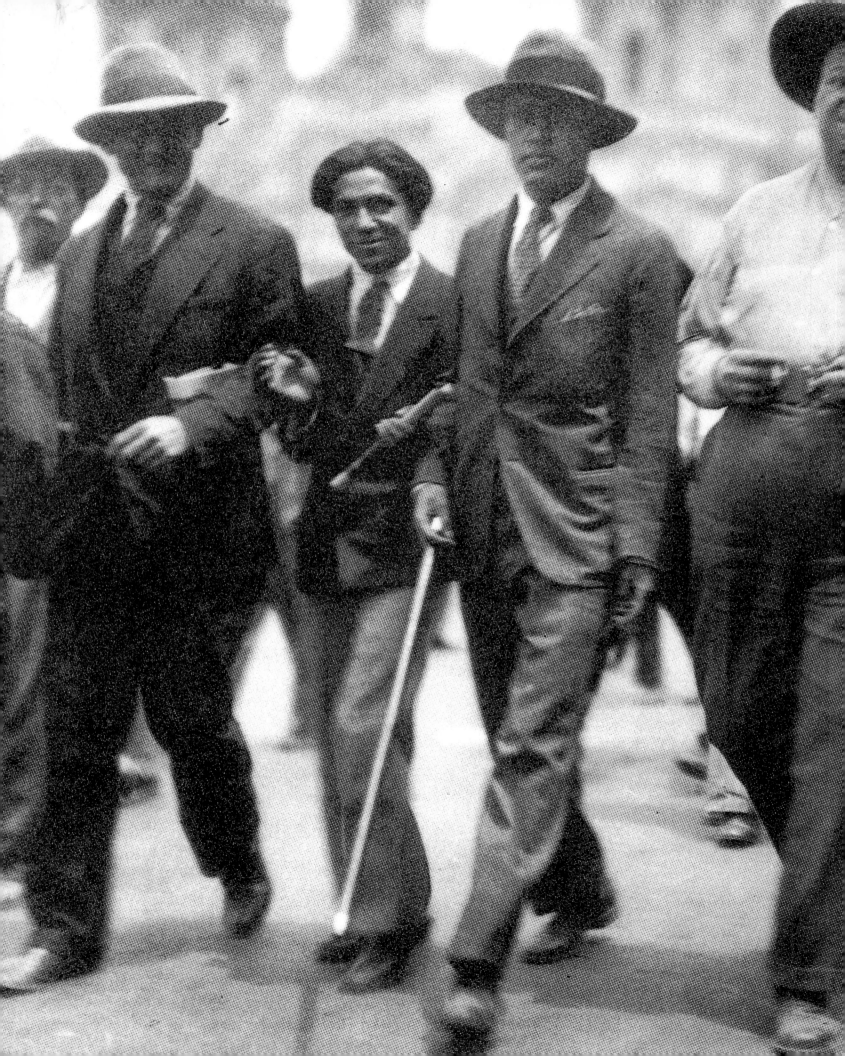

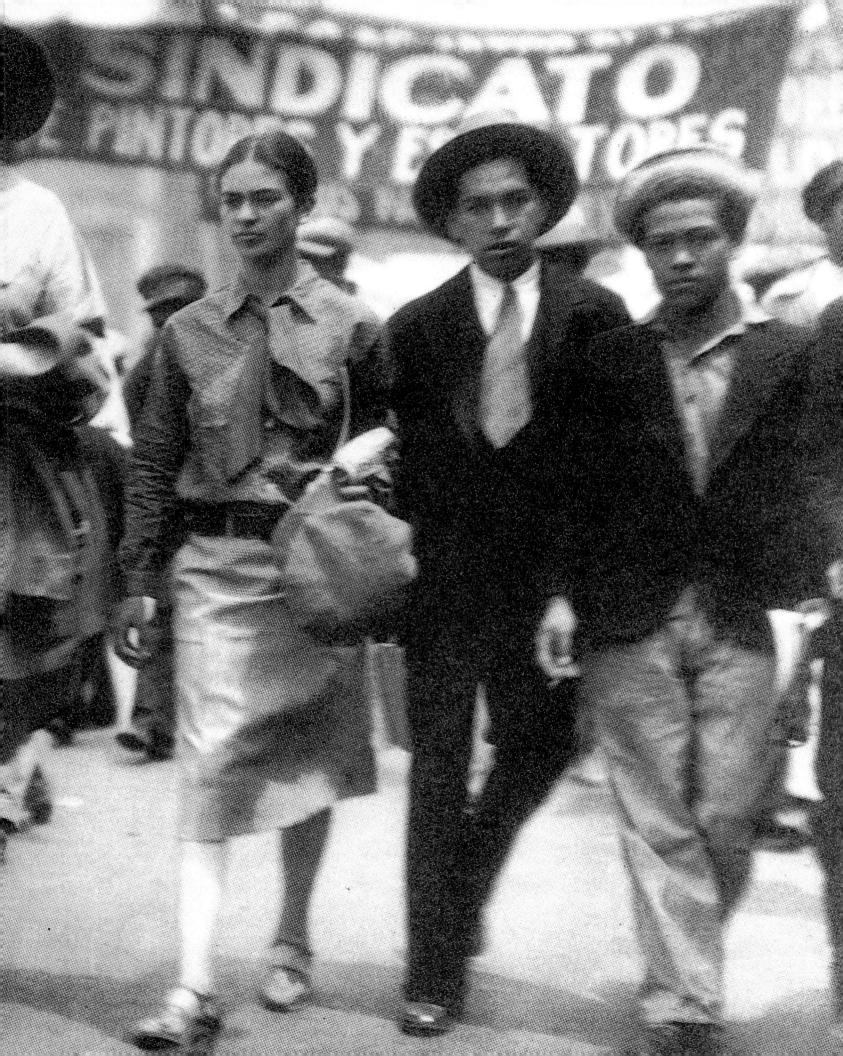

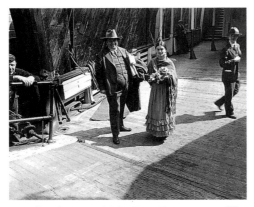

Frida's boyfriend, "beloved Alex," succumbed to his family's pressure and broke with Kahlo during the period when she was convalescing. She faced her loss by tapping into her intense desire for life. When she returned home after three months in the hospital, Frida began to paint with her father's oils on an easel specially designed so she would not have to sit up. "I paint myself because I am so often alone, because I am the subject I know best," she said.

Throughout her life Kahlo was bedridden for long periods of time and fitted with body casts. The compound injuries and pain would eventually take their toll, resulting in her death at age forty-seven in 1954. Her friend the photographer Lola Alvarez Bravo explained that after the streetcar accident, "The struggle of two Fridas was in her always, one dead Frida and one Frida that was alive." By Kahlo's own account, she considered the two major events in her life to be accidents. "The first," she said, "was when a streetcar knocked me down, and the second was Diego."

Frida first met Diego Rivera in 1922 when he was thirty-six, world-famous, and had just returned from Europe. He was working on *Creation*, his mural for the National Preparatory School where Frida attended classes. Their relationship, however, did not begin until 1928 when they met again at gatherings held at Tina Modotti's apartment in Mexico City. Modotti, who had come to Mexico in 1923 with Edward Weston, became a photographer and stayed on after Weston's return to California. She modeled for Rivera for his National Agricultural School murals and, some believe, had an affair with him.

Kahlo and Rivera's relationship was tempestuous, full of passion, camaraderie, betrayals, and tenderness. Perhaps the best description of the strong bonds between them is conveyed in Frida's "Portrait of Diego," which she wrote in 1949:

> Diego. *Beginning*
> Diego. *constructor*
> Diego. *my baby*
> Diego. *my boyfriend*
> Diego. *painter*
> Diego. *my lover*
> Diego. *"my husband"*
> Diego. *my friend*
> Diego. my mother
> Diego. me
> Diego, universe
> Diversity in *Unity*
> Why do I call him *My* Diego?
> He never was not ever will be mine.
> He belongs to himself.

It was only after Frida's marriage to Diego in 1929 that she began to wear traditional Mexican dress. She had become a member of the Mexican Communist party and emphasized her *mestiza* or half-Indian ancestry and her *mexicanista* sympathies. Frida's costumes added to the theatricality of her life. According to the writer Luis Cardoza y Aragon: "Frida was grace, energy, and talent united in one of the beings who has most stirred my imagination to enthusiasm. Diego and Frida were part of the spiritual landscape of Mexico, like Popocatepetl and Ixtaccihuatl in the valley of Anáhuac."

While most famous Mexican movie stars of the time, including Dolores del Rio and María Felix, only wore *mexicanista* clothes in their Hollywood films, preferring the fashions of Paris and New York, Frida chose traditional Mexican dress as part of her lifestyle. Gliding through the streets of New York, San Francisco, or Paris, Kahlo emanated a strange and magical beauty. Rivera, who encouraged and supported her choice of traditional dress, said: "The classic Mexican dress has been created by people for people. The Mexican women who do not wear it, do not belong to the people, but are mentally and emotionally dependent on a foreign class to which they wish to belong, to the great American and French bureaucracy." Frida herself admitted that while she often wore pants, when she took Rivera his lunch at one of the mural sites she would wear the Tehuana costume, from the matriarchal culture of the region of Oaxaca. Bernard Silberstein posed Kahlo in this costume in 1943 (page 53). Standing out from the objects she resembles, Kahlo seems caught in time, alone, impassive, and strangely dispassionate, her face the mask she so often painted.

She took great care in styling her long, dark hair, braiding it in various styles with brightly colored woolen yarn like the Cuetzalan, Puebla, and *Otomie* women, or using a variety of *peinetas*, popular, small, decorative combs she would buy in the market. Along with fresh flowers from her garden, these decorative accessories added to the *mexicanista* look. When Imogen Cunningham made an early series of portraits of Frida in San Francisco in December 1930, it was Kahlo's first trip outside of Mexico (pages 13 and 25). In these pictures Frida is adorned with pre-Columbian jewelry—heavy beads, a jadeite Olmec pendant, Aztec motif earrings—and a *rebozo* or shawl. She projects an ethnic pride and could be of royal Mexican ancestry.

During this trip to San Francisco Kahlo met the photographer Edward Weston, whom she had learned about from Tina Modotti in Mexico (page 104). Impressed with Kahlo, Weston wrote in his diary:

"His [Rivera's] new wife—Frieda [sic]—too: she is in sharp contrast to Lupe [Marín, Diego's third wife] . . . petite—a little doll alongside Diego, but a doll in size only, for she is strong and quite beautiful, shows very little of her father's German blood. Dressed in native costume even to *huaraches*, she causes much excitement in the street of San Francisco. People stop in their tracks to look in wonder."

From California, Kahlo and Rivera traveled to New York where they met Lucienne Bloch, the photographer and artist who became Frida's close friend, her American *cuate*. Bloch assisted Rivera with his Rockefeller Center murals, photo-

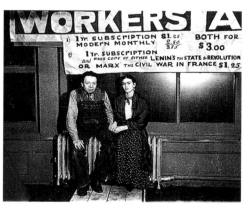

Lucienne Bloch, 1933, New York City. Kahlo and Rivera at the New Workers School.

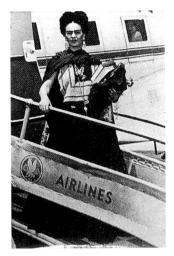

Photographer unknown, 1940s. Kahlo on a visit to the United States.

graphed the process, and took the last pictures of the murals before Nelson Rockefeller ordered them destroyed because they had incensed a public who found them anti-capitalism. Kahlo and Bloch enjoyed each other's company; they went to the movies, drew together, cracked jokes, and sang off-color Mexican songs. Bloch made a unique series of photographs of Kahlo showing off, having fun, mimicking for the camera— expressing the fun-loving daredevil side she usually hid from photographers (pages 33 and 39–41).

While Frida and Rivera were in Detroit in 1932, where Rivera was painting murals for the Ford Motor Company, Kahlo's mother became ill. Bloch accompanied Frida by train on her return to Mexico. Bloch, whose Leica camera had broken, took several pictures of her friend with the Kodak Brownie snapshot camera she had brought along (pages 28-29). In these pictures, Kahlo resembles a *soldadera Adelita*, one of the Mexican peasant women who accompanied their husband by train during the revolution. Frida wears the long, cotton ruffled skirt and *rebozo* typical of the *Adelitas*.

A few days after her mother's death, Frida's father made a portrait of his daughter in which she is on the verge of tears, unashamedly revealing her grief (page 26). Although she rejoined Rivera in the United States, Frida soon became homesick; she missed her family and friends and her country. On her insistence, Rivera agreed to return to Mexico, where their friend, the painter and muralist Juan O'Gorman, had redesigned their San Angel home and studio with a new connecting wing for Frida. There they settled back into life in Mexico.

Sometime during 1934 Rivera began an affair with Kahlo's sister, Cristina. Frida moved out of their home, rented a small apartment in Mexico City, and took off for New York with friends, where she met up with Bloch, who had married Stephen Dimitroff, an assistant to Rivera. Two photographs by Bloch during this period capture Kahlo's remarkable spirit (pages 34 and 35). "She had cut her hair and wore American clothes as a reaction to Diego's affair with Cristina," Bloch remembers. In one picture Kahlo has covered her short hair with a lace doily in the style of the Tehuana headdress. Her expression is melancholic, mixing outward humor with inner pain, but her eyes reveal her ever-present pride.

In another photograph by Bloch, Kahlo stares mistily into the lens, cradling a bottle of Cinzano like the baby she was not able to have (page 35). Frida points to the bottle as if it might offer the answer to her emotional wounds. Bloch knew that Frida wanted a child with Rivera and that the two medical abortions she had undergone had only increased her desire to become a mother. But poor health made a successful pregnancy impossible. Having just given birth to a child of her own, Bloch asked Frida to become her baby's godmother, which Kahlo accepted.

Except for *Self-Portrait with Curly Hair* and *A Few Small Nips*, Frida did not paint much that year. It was a traumatic time in her life, but she was determined to maintain her marriage with Rivera. She returned to Mexico and forgave her sister. Referring to Rivera's infidelities, she said, "I cannot love him for what he is not." Kahlo was beginning to understand that only by becoming an independent woman would she win Rivera's true admiration.

Manuel Alvarez Bravo, declared by André Breton to be Mexico's preeminent surrealist photographer, made several portraits of Kahlo around this time. In one, Frida sits beside a large reflecting ball, resting as if in a Flemish painting, elegant and timeless, an inhabitant of her own world (page 37). Another photograph features a ripped dress flapping from a clothesline on the roof of Kahlo's house (page 47). Kahlo had already painted *Memory or the Heart* and *My Dress Hangs There or New York*. Alvarez Bravo identified Kahlo with the peasant dignity of labor and the rural Mexican women who spend a good deal of their time washing clothes by hand. On another level, the picture conjures up the absence of a body to fill the dress. Frida, very much alive, stands in contrast.

In the late 1930s, after Rivera's affair with Cristina, Kahlo slowly evolved into a more independent woman and emerged as a more complex personality. Raquel Tibol, the Argentine-born, Mexican art critic and writer, has commented, "Their marriage was not one of 'free love,' but an open marriage."

It was a period when life was an experiment for Frida, who from childhood on had been a curious, adventuresome, agile-minded student, rejecting what she considered to be middle-class hypocrisies. Frida began to flaunt her identity, as a woman, a Mexican, and a sexual person. Her friend Lucienne Bloch recalled: "Diego astonished me when he pointed at Frida and said, 'You know that Frida is a homosexual, don't you?'" She flirted with Georgia O'Keeffe and Jacqueline Lamda, André Breton's wife, both of whom she wrote about openly in her letters. She used her sister Cristina's and other friends' houses to meet lovers, keeping her affairs—with men and women—discreet because of Rivera's intense jealousy.

From the 1930s until the end of World War II, Mexico was a magnet for artists and intellectuals who were escaping from fascism or exploring Mexico's diverse cultures. Marsden Hartley, John Dos Pasos, Waldo Frank, Antonin Artaud, Louise Bourgeois, André Breton, Leonora Carrington, Sergei Eisenstein, Isamu Noguchi, Milton Avery, Philip Guston, D. H. Lawrence, and others came to Mexico and met Kahlo and Rivera.

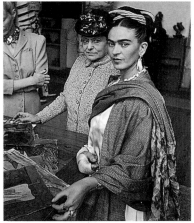

Frida, in her ornate Mexican attire, became a center of attention among the intellectual celebrities who sought out the great muralist Rivera. In January 1937 Leon Trotsky, who had been invited by Rivera to take up exile in Mexico, arrived with his wife Natalia Sedova. Diego, recently hospitalized with kidney problems, sent Frida to meet the couple's boat in Tampico harbor. Soon the Trotskys settled into Casa Azul, the house in which Frida was born and had recently refurbished. Trotsky's reputation, his intellect, and his love of women attracted Kahlo, and shortly after their arrival Frida and Trotsky began an intense, short-lived affair. When Frida broke off the relationship, she said, "*Estoy muy cansada del viejo*" (I am tired of the old man). According to Trotsky's secretary, "It was impossible to go on without committing themselves or without an incident with Natalia, Diego, or the Party [Communist party]." One of Frida's self-portraits, which she dedicated to Trotsky after their affair had ended, prompted Breton to write, "Frida Kahlo's paintings are like a ribbon around a bomb."

Emmy Lou Packard, ca. 1940, San Angel, Mexico City. Kahlo with Helena Rubinstein at Rivera's studio.

Following pages: Photographer unknown, 1937, Tampico harbor. Kahlo en route to meet Leon Trotsky on his arrival in Mexico.

113

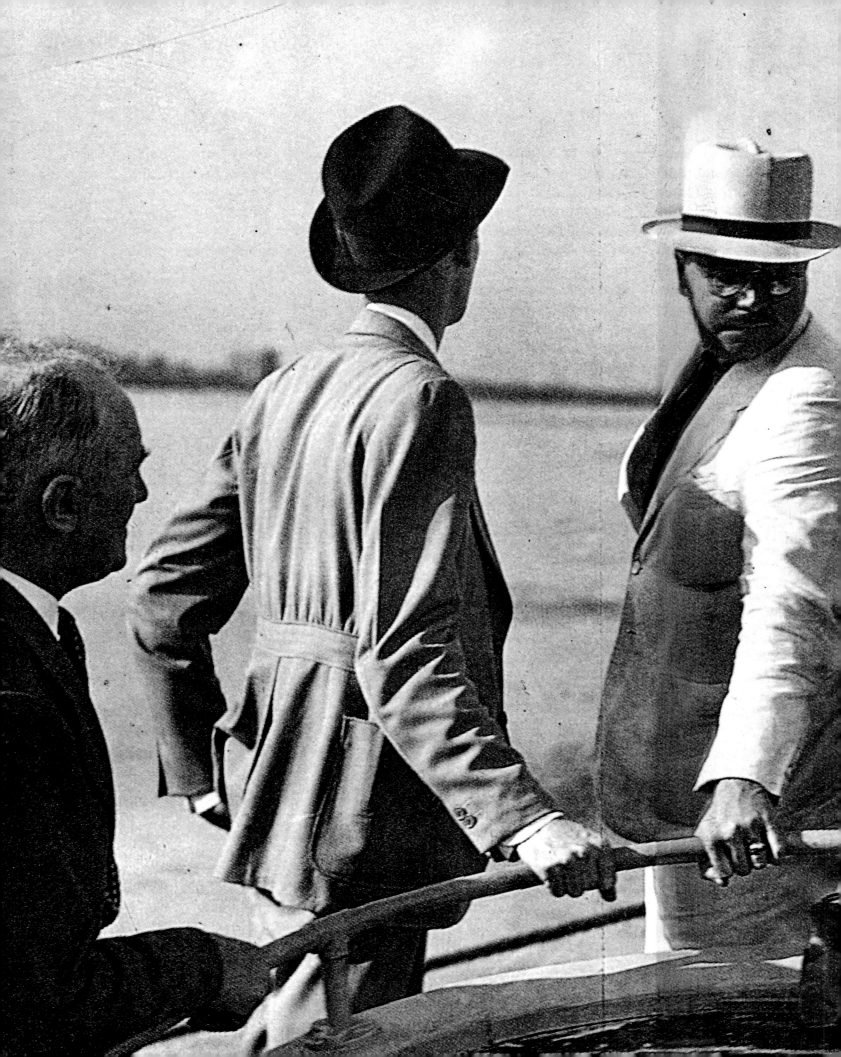

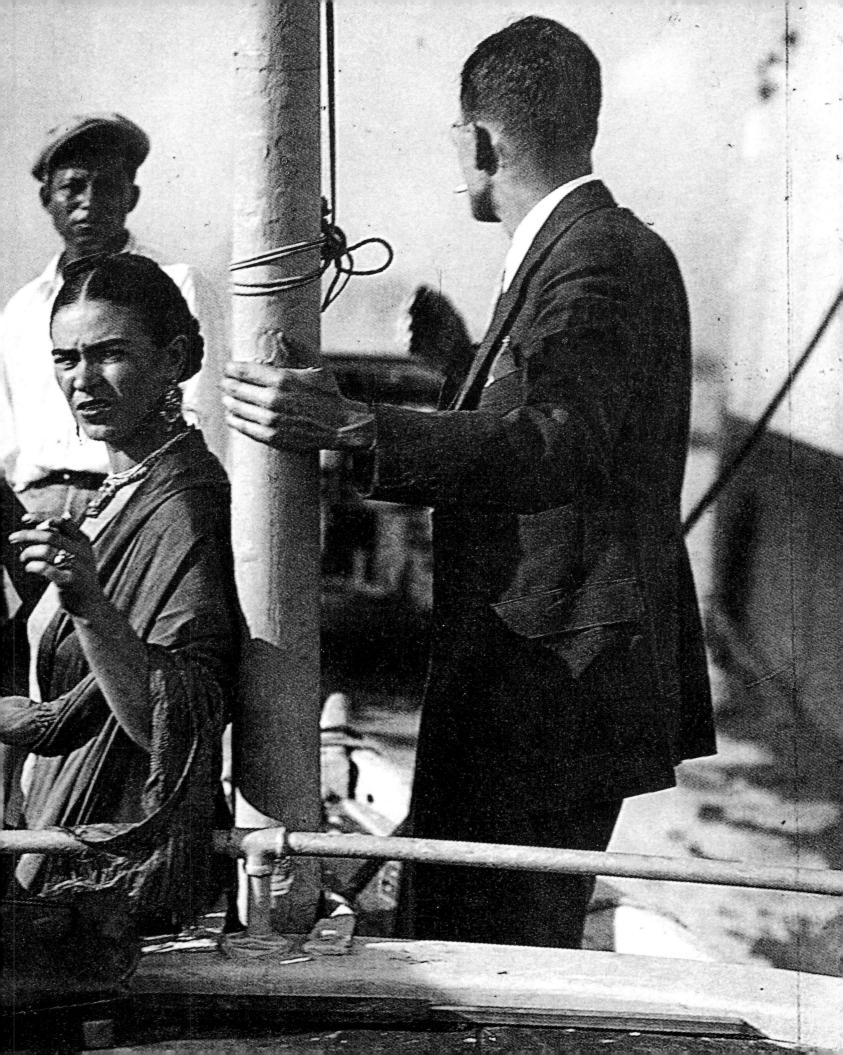

Between 1937 and 1938, Kahlo painted twenty-seven paintings and was invited to exhibit at the prestigious Julian Levy Gallery in New York. It was there that her relationship with Nikolas Muray, a photographer for *Vanity Fair*, began and flourished. They had first met in Mexico, probably through the painter and caricaturist Miguel Covarrubias, who was a colleague of Muray's at the magazine. Muray's portraits of celebrities had made him successful, and the images he took of Frida glamorized her by heightening her *mexicanista* style. Muray asked Frida to tilt her head so that her already feline eyes took on the quality of the female faces in Rivera's murals. At the same time Kahlo's eyes steadfastly and seductively held the eye of Muray's lens.

Kahlo wrote to Muray from Paris where she traveled to attend a show organized by Breton that included her paintings, "I am so happy to think I love you to think you wait for me—you love me." Although deeply in love with Muray, she missed Mexico and Rivera. Frida was unhappy in Paris; she did not speak French well or get along with Breton. She ended up in a hospital with a kidney infection from drinking more than a bottle of cognac a day while she was waiting for the show to open. According to Frida, the show had lots of "junk Breton bought at the market, plus fourteen portraits of the nineteenth century and thirty-two photographs by Manuel Alvarez Bravo. They make me vomit. They are so damn intellectual and rotten that I can't stand them any more. It is really too much for my character. I'd rather sit on the floor in the market of Toluca and sell tortillas, than to have anything to do with those 'artistic' bitches of Paris . . ." She met "*las grandes cacas del surrealismo*" (big surrealist shits), but disclaimed publicly that she was one of them. She did, however, like Marcel Duchamp and his friend Mary Reynolds with whom she ended up staying.

After her return to Mexico in 1940, Frida and Diego divorced. The reasons reported were manifold, but it was Diego who promoted the break. To make matters worse, Muray had also broken with Frida and married someone else.

Rivera left for San Francisco to complete a commissioned mural for the San Francisco Golden Gate International Exhibition, "Art in Action." In May 1940 his car and chauffeur in Mexico were involved in

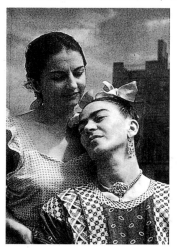

Photographer unknown, 1946, Coyoacán, Mexico. Kahlo and her sister Cristina.

Trotsky's assassination. Frida's bad health deteriorated drastically after Trotsky's death, and Diego became increasingly concerned. Through Dr. Leo Eloesser, Kahlo's doctor and trusted friend, he asked Frida to remarry him. After the suspicions circulating about Rivera's involvement in Trotsky's death were dispelled, Frida flew to San Francisco where she was hospitalized. When she was released she traveled to New York with Heinz Berggruen, an art dealer to whom Rivera had introduced her. In New York they stayed at the Barbizon Plaza Hotel and had a tumultuous two-month affair while Kahlo was planning her show at the Julian Levy Gallery. Finally she agreed to remarry Rivera on his fifty-fourth birthday, December 8, 1940, in San Francisco. Frida's former lover Muray made a series of wedding portraits following the ceremony. They show a respectable couple, with Rivera holding his trademark Stetson hat (page 49), and two fun-loving people kissing and holding hands (pages 48, 50–51).

By contrast, the photograph by Fritz Henle made three years later in

1943 of Frida painting in her Casa Azul studio, reveals a woman as intense and still as the pre-Columbian objects that surround her (page 66). Inner explosiveness boils behind her mask-like face.

The only portrait in which Kahlo emits the serenity that her second marriage to Rivera brought her is the photograph by Emmy Lou Packard (page 56). Frida, dressed in blue jeans and a boy's plaid jacket with fresh flowers in her hair, hugs her husband in their dining room. These were the years of World War II during which Kahlo and Rivera's struggle against fascism was curtailed by Rivera's relationship with the Communist party. Kahlo's health suffered, and she mourned her father who had died in 1941. Deeply depressed, she saw the outer world as a chaos of destruction and death.

In her own slightly more controlled world, Kahlo kept all sorts of pets—her spider-monkeys Fulang-Chang and Caimito de Guayabal; Granizo, a deer; Bonito, a parrot; Sr. Xolotl, her iztcuintli dog; and Gertrude Caca Blanca, a pet eagle. She cultivated assorted native plants, cacti, and a small *milpa* (corn patch). On the patio of Casa Azul, Frida placed pre-Columbian stone carvings and inserted abalone seashells into the walls along with Mexican blue sheet-metal mirrors.

Gisèle Freund, a French photographer working in Mexico from 1951 to 1952, photographed Kahlo in her garden as an integral part of nature, in unity with her environment. Freund's photograph of Frida on her patio (pages 64–65), showing her smoking next to a pre-Columbian statue, is a portrait of an ancient, silent witness whose presence underscores Frida's battle with exhausting emotional and physical pain. In an embrace with her spider-monkey Fulang-Chang, another portrait by Fritz Henle made in 1943 (page 63), Frida's eyes seem to stare inward, projecting a mood similar to the mask-like face she painted that same year in *Self-Portrait Thinking About Death*.

As Frida became increasingly confined to her home due to deteriorating health, the spiritual, healing aspects of nature comforted her, bringing her back to her roots, to nature's cycle of life and death. In 1947 Frida's nephew Antonio Kahlo photographed her dressed in Chinese pajamas smoking her ubiquitous cigarette, which was often marijuana (page 73). The photograph, showing Kahlo's hair loose, is as unusual as her painting *Self-Portrait with Loose Hair* that Frida made the same year in celebration of her fortieth birthday.

Hector García, a renowned Mexican photojournalist, spent time with Frida at Casa Azul in 1949 when she was often confined to her bed. In the photographs her depression and anxiety are apparent (pages 74–77); she seems absorbed with her agonizing pain. Spinal operations, morphine, and other drugs have taken their toll. It was the same year that Rivera began an affair with the actress María Felix, whom he asked to marry him. When she refused, Rivera returned to Kahlo.

In the painting *Love Embrace of the Universe, the Earth (Mexico), Diego, Me, and Sr. Xolotl*, seen next to Frida in García's photograph (page 79), Kahlo portrays herself as Rivera's mother, an ancient goddess holding Diego like an Olmec baby. The division of light and darkness, the sun and the moon, and the cycles of the universe are a part of her, and she is a part of them. Diego, to whom she has given

Manuel Alvarez Bravo, 1944, Mexico City. At a Picasso exhibition at Sociedad de Arte Moderno.

117

birth, is represented as a continuation of herself. In another photograph García captured the mood of the painting when he photographed Frida cuddling with her dog Sr. Xolotl on her bed, covered with Mexican textiles. In the photograph, she *is* at one with the universe, the life giving force of creation, the center.

The sensitive photographs of Frida's friend Lola Alvarez Bravo, taken from the early 1940s until 1953, project a mature Frida, emerging during the years of psychological and physical upheaval (pages 8, 70–71). They portray a woman reconciling herself with life and drawing on a wisdom that gives her a measure of peace. By Bravo's account, when Frida was not feeling well, Rivera would telephone Bravo and ask her to visit. Bravo would bring her camera, and the two friends would talk while Lola made photographs.

In 1950 Kahlo spent most of the year in the hospital due to an infection provoked by a spinal insert. By mid-April she had already undergone two operations. With the help of Demerol injections, casts, and visits from family and friends, she managed to paint and eventually return to her home, but only after five more operations.

One of her preferred doctors at that time, Juan Farill, founder of a hospital for lame children, was the inspiration for her 1951 *retablo* painting *Self-Portrait with Portrait of Dr. Farill*. The painting is Frida's testimony that Farill had saved her life, and in the work she offers him her heart-shaped palette in affectionate appreciation. Gisèle Freund portrayed the doctor and his patient in a pose similar to the one that Kahlo depicted in her *retablo* (page 83).

As Frida's health continued to decline, she became more and more dependent on Rivera, the world of Casa Azul, and the people who visited her. She expressed an urgent need to serve the Communist party when she said: "I should struggle with all my strength for the little that is positive that my health allows me to do in the direction of helping the Revolution. The only real reason to live." She continued to want to transform her art into something "useful," but painting became increasingly more difficult. Finally, in 1953, her right leg was amputated.

In the photographs by the Brothers Mayo, important Mexican photojournalists, Frida represents the Mexican revolutionary woman with an undefeated physical presence (pages 92–96). Her face is marked with years of suffering, but she projects a masculine strength, dragging on her cigarette as if she were drinking and debating with her *cuates*. Her pronounced mustache and peasant *Mazahua* dress accentuate the image of a politically committed woman. At the time she said, "I continue to be a Communist, absolutely, and now, anti-imperialist, because our line is that of peace."

Throughout her demanding and difficult life, Frida shaped and modeled many roles, defining her ethnic origins, her passion for and devotion to Diego, and all that she loved around her. In these many photographs taken during her life, the viewer is invited to penetrate the mask she consciously designed, and to be emotionally moved by the ways in which she shifted and changed to create her persona. Although she often seemed to live on the center of a theatrical stage, Frida's face revealed the truth she lived and struggled for. Together these photographic portraits show Frida Kahlo as the irresistibly sensual, multifaceted, mythological woman she became. Admired by the people who photographed her, she fulfilled their desire and became an emblematic reference for artists and art historians. For many others Frida became immortal, an icon.

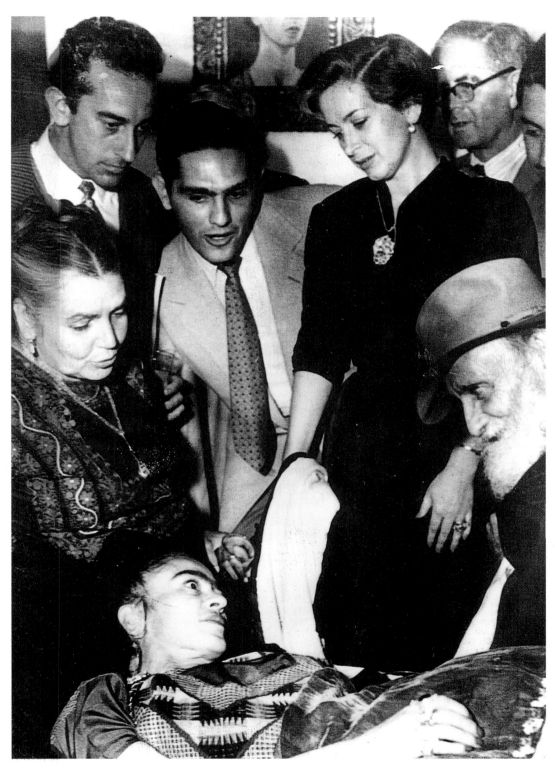

Photographer unknown, 1953, Mexico City. Kahlo was carried in her own bed to the opening of her first one-person exhibition of paintings in Mexico organized by Lola Alvarez Bravo. She is sur – rounded by Concha Michel, Antonio Pelaez, Dr. Roberto Garza, Carmen Farell, and Dr. Atl.

C A P T I O N S

PAGE 8

Lola Alvarez Bravo, 1947, Coyoacán, Mexico. Kahlo poses in her bedroom in Casa Azul, her house in the Coyoacán neighborhood on the outskirts of Mexico City. Rivera's painting, *Nocturnal Landscape*, hangs on the wall. Lola Alvarez Bravo, who was the darkroom printer for her husband Manuel, met Kahlo in the late 1930s and photographed her throughout their friendship. It was Bravo who, with Rivera's daughter Ruth, dressed Kahlo for her public funeral. *Galería Juan Martin, Mexico City.*

PAGE 13

Imogen Cunningham, 1930, San Francisco. Kahlo first traveled to the United States accompanying Rivera who was painting murals at the San Francisco Stock Exchange. Cunningham was, at the time, a fashionable portrait photographer as well as a member of the f/64 Group, which included Ansel Adams and Edward Weston. *The Imogen Cunningham Trust, Berkeley, California.*

PAGE 25

Imogen Cunningham, 1930, San Francisco. *The Imogen Cunningham Trust, Berkeley, California.*

PAGE 26

Guillermo Kahlo, 1932, Mexico City. Kahlo's father, a German-born professional photographer who settled in Mexico in 1891, took this portrait of his daughter a few days after her mother's death. *Courtesy of S. Throckmorton and C. Stellweg, New York.*

PAGE 27

Lucienne Bloch, 1933, New York City. Kahlo sits below the painting *Self-Portrait, 1933*, in her room at the Barbizon Hotel. She accompanied Rivera to New York where he was to work on murals for Rockefeller Center. *Courtesy of the photographer.*

PAGE 28

Lucienne Bloch, 1932, Laredo, Texas. While in Detroit, where Rivera was painting murals on the theme of modern industry for the Ford Motor Company, Kahlo learned her mother was gravely ill. Accompanied by her friend, photographer Lucienne Bloch, Kahlo returned to Mexico by train. This informal photograph was taken as they waited to cross the border from the United States into Mexico. *Courtesy of the photographer.*

PAGE 29

Lucienne Bloch, 1932. En route from Detroit to Mexico. *Courtesy of the photographer.*

PAGE 31

Manuel Alvarez Bravo, ca. 1930. From the start, Kahlo and Rivera's marriage was unconventional. She commented: "Diego is not anybody's husband and never will be, but he is a great comrade." *Courtesy of the photographer and The Witkin Gallery, Inc., New York.*

PAGE 32

Lucienne Bloch, 1933, New York City. Kahlo poses before one of Rivera's murals-in-progress at the New Workers School (later renamed The New School for Social Research). After his Rockefeller Center murals were rejected for their overt critique of capitalism and then destroyed, Rivera painted a cycle of frescos at the New Workers School without a fee. *Courtesy of the photographer.*

PAGE 33

Lucienne Bloch, 1933, New York City. At the New Workers School, Kahlo wears a photolamp as a hat. *Courtesy of the photographer.*

PAGE 34

Lucienne Bloch, 1935, New York City. After learning of Rivera's affair with her sister Cristina, Kahlo cut her long hair that Rivera loved and traveled to New York with two friends. *Courtesy of the photographer.*

PAGE 35

Lucienne Bloch, 1935, New York City. Kahlo spontaneously pulled a lace cloth made by Bloch's mother off a nearby table in Bloch's apartment and pretended it was a native Tehuana costume. *Courtesy of the photographer.*

PAGE 37

Manuel Alvarez Bravo, 1938, Coyoacán, Mexico. Kahlo poses next to a painted mercury ball in the hallway of Casa Azul. Manuel Alvarez Bravo, one of Mexico's most renowned photographers, was a favorite of André Breton and the French surrealists in the 1930s. *Courtesy the photographer and The Witkin Gallery, Inc., New York.*

PAGE 38

Peter A. Juley & Son, 1930, San Francisco. Kahlo and Rivera pose with the American artists Lucille and Arnold Blanch. The Juleys ran a commercial studio in New York City and traveled to Mexico to photograph Rivera. *Peter A. Juley & Son Collection, National Museum of American Art, Smithsonian Institution, Washington, D.C., and the Philadelphia Museum of Art.*

PAGE 39

Lucienne Bloch, 1933, New York City. *Courtesy of the photographer.*

PAGES 41

Lucienne Bloch, 1933, New York City. *Courtesy of the photographer.*

PAGE 43

Guillermo Davila, n.d., Xochimilco,

120

Mexico. On Sundays Kahlo often visited Xochimilco, a Venice-like resort on the outskirts of Mexico City. Davila and his partner Francisco Iturbe opened the first commercial art gallery in Mexico City in the 1920s. *Fotos Archivo CENIDIAP-INBA, Mexico City.*

PAGE 44
Fritz Henle, 1937, Xochimilco, Mexico. *Photo Researchers, Inc., New York.*

PAGE 45
Manuel Alvarez Bravo, ca. 1937, Coyoacán, Mexico. Kahlo paints *Itzcuintli Dog with Me.* Although she had not yet publically shown her paintings in Mexico, Kahlo had her first exhibition in New York at the prestigious Julien Levy Gallery in 1938. *Courtesy of the photographer and The Witkin Gallery, Inc., New York.*

PAGE 47
Manuel Alvarez Bravo, ca. 1937, Coyoacán, Mexico. Bravo's photograph, taken on Kahlo's roof, incorporates a hanging dress, a symbol that Kahlo used in her paintings *Memory*, 1937, and *My Dress Hangs There or New York*, 1933. *Courtesy of the photographer and The Witkin Gallery, Inc., New York.*

PAGE 48
Nickolas Muray, ca. 1940, San Francisco. Muray, a photographer for *Vanity Fair* was introduced to Kahlo in Mexico City in 1937 by Miguel Covarrubias, who contributed caricatures and drawings to the magazine. A well-known fashion and portrait photographer, Muray was a pioneer in color photography. His affair with Kahlo began in 1938 and lasted for more than a year. Muray photographed Kahlo and Rivera shortly after their remarriage. Rivera holds the gas mask he often

used while painting. *International Museum of Photography, George Eastman House, Rochester, New York.*

PAGES 49–51
Nickolas Muray, ca. 1940, San Francisco. *International Museum of Photography, George Eastman House, Rochester, New York.*

PAGE 53
Bernard G. Silberstein, 1942, Coyoacán, Mexico. Kahlo, wearing the traditional Tehuana costume, stands before her collection of popular Mexican ceramics. *Courtesy of the photographer.*

PAGE 54
Nickolas Muray, ca. 1940, San Francisco. *International Museum of Photography, George Eastman House, Rochester, New York.*

PAGE 55
Diego Rivera, 1941, Coyoacán, Mexico. Kahlo poses with Emmy Lou Packard, an American painter who was one of Rivera's assistants and who became Kahlo's close friend. Kahlo arranged Packard's hair in a Mexican style for this photograph, which Rivera took with Packard's camera. *Courtesy of Don Beatty, San Francisco.*

PAGE 56
Emmy Lou Packard, 1941, Coyoacán, Mexico. Kahlo and Rivera embracing in the dining room of Casa Azul. *Courtesy of Don Beatty, San Francisco.*

PAGE 57
Nickolas Muray, ca. 1940, San Francisco. *International Museum of Photography, George Eastman House, Rochester, New York.*

PAGE 59
Emmy Lou Packard, 1940s, Coyoacán, Mexico. Photographed in the

courtyard of Casa Azul, Kahlo wears blue jeans either as a rebellious gesture or as an homage to workers. *Courtesy Don Beatty, San Francisco.*

PAGE 60
Leo Matiz, 1942, Coyoacán, Mexico. Matiz, a well-known Colombian photographer and a friend of Rivera's who shared his fervent nationalism, came to Mexico City in 1939. *Courtesy of Alexandra Matiz, Milan.*

PAGE 61
Nickolas Muray, 1940s, Coyoacán, Mexico. Kahlo, with her pet deer Granizo, also kept parrots, monkeys, dogs, rabbits, and ducks as pets. Symbolic spirits in pre-Columbian mythology, these animals also figured prominently in her paintings. *International Museum of Photography, George Eastman House, Rochester, New York.*

PAGE 63
Fritz Henle, 1943, Coyoacán, Mexico. Kahlo poses with her pet monkey, Fulang-Chang, an animal she incorporated into many of her self-portraits. Henle, who was sent to Mexico on assignment and stayed for a year, was Kahlo's neighbor and photographed her working at home. *Photo Researchers, Inc., New York.*

PAGES 64–65
Gisèle Freund, ca. 1951, Coyoacán, Mexico. In the courtyard of Casa Azul, Kahlo poses next to a basalt statue of a pre-Columbian deity. Kahlo often used drugs, including marijuana and alcohol, as painkillers and sedatives. *Photo Researchers, Inc., New York.*

PAGE 66
Fritz Henle, 1943, Coyoacán, Mexico. Casa Azul was filled with collections of dolls, toys, folk art, popular ce-

ramics, pre-Columbian art, textiles, and jewelry. *Photo Researchers, Inc., New York.*

PAGE 67

Bernard G. Silberstein, 1943, Coyoacán, Mexico. Kahlo with *The Wounded Table*, one of her largest paintings. Assigned to photograph the Mexican muralist painters Rivera, José Clemente Orozco, and David Siquieros for an American picture agency, Silberstein became more interested in Kahlo as a photographic subject and made a series of photographs of her. *Courtesy of the photographer.*

PAGE 69

Bernard G. Silberstein, 1945, Coyoacán, Mexico. *Courtesy of the photographer.*

PAGE 70

Lola Alvarez Bravo, 1944, Coyoacán, Mexico. Above Kahlo's dressing table a lyre-shaped frame holds the double portrait of Kahlo and Rivera, *Diego and Frida, 1929–1944*, which Kahlo painted to celebrate their fifteenth wedding anniversary. *Galería Juan Martin, Mexico City.*

PAGE 71

Lola Alvarez Bravo, 1947, Coyoacán, Mexico. *Galería Juan Martin, Mexico City.*

PAGE 73

Antonio Kahlo, 1947, Coyoacán, Mexico. Taken by her nephew, Cristina's son, this photograph is unusual because Kahlo, wearing exotic Chinese pajamas, allowed herself to be photographed with her hair down. *Courtesy of Cristina Kahlo, Mexico City.*

PAGES 74–77

Hector García, 1949, Coyoacán, Mexico. As Kahlo's health deteriorated,

she was often confined to bed where she painted and received friends and visitors. García, an important Mexican photojournalist, was part of the Mexico City intellectual circle that included Kahlo and Rivera. *Courtesy of the photographer.*

PAGE 79

Hector García, 1949, Coyoacán, Mexico. Kahlo poses before her painting *The Love Embraces*, which depicts herself, Diego, and Kahlo's dog Sr. Xolotl protected by the female creator of the universe. *Courtesy of the photographer.*

PAGE 81

Bernice Kolko, 1952, Coyoacán, Mexico. Kahlo in bed at her home. A European emigré, Kolko photographed post-revolutionary Mexico and its artists. *Fotos Archivo CENIDIAP-INBA, Mexico City.*

PAGE 82

Nickolas Muray, 1940s, Coyoacán, Mexico. Doctors used traction to relieve Kahlo's spinal pain whenever it became unbearable. *The International Museum of Photography, George Eastman House, Rochester, New York.*

PAGE 83

Gisèle Freund, 1952, Coyoacán, Mexico. Kahlo and her friend and surgeon Dr. Juan Farill stand beside *Self-Portrait with Dr. Farill*, painted in 1951. *Photo Researchers, Inc., New York.*

PAGES 84–85

Juan Guzmán, 1952, Mexico City. Kahlo, often unable to work standing up, frequently painted in bed. Photographed in the ABC Hospital, Kahlo works on *My Family*. Guzmán was a German photographer who changed

his name, Johan Gutman, to Juan Guzmán. *Fotos Archivo CENIDIAP-INBA, Mexico City.*

PAGE 86

Gisèle Freund, 1952, Coyoacán, Mexico. Kahlo in her bedroom in Casa Azul. *Photo Researchers, Inc., New York.*

PAGE 87

Juan Guzmán, 1952, Mexico City. Kahlo poses for Rivera as he paints her image in his mural *Nightmare of War, Dream of Peace* at the Palace of Fine Arts. *Fotos Archivo CENIDIAP-INBA, Mexico City.*

PAGES 88–89

Guillermo Zamora, ca. 1953, Coyoacán, Mexico. Kahlo in her garden at Casa Azul. Zamora, a Mexican photographer famous for his images of architecture, became friends with Rivera and Kahlo in the 1950s and photographed them in their studios. *Fotos Archivo CENIDIAP-INBA, Mexico City.*

PAGE 91

Gisèle Freund, 1952, Coyoacán, Mexico. Kahlo, posing in front of corn plants, recalls the corn goddess Xochipilli from Mexican mythology who was also the goddess of poetry, literature, and dance. *Photo Researchers, Inc., New York.*

PAGES 92–96

The Brothers Mayo, 1953, Coyoacán, Mexico. Confined to a wheelchair after the amputation of her leg by Dr. Farill in 1953, Kahlo is dressed in a peasant-style Mazahua dress. These pictures, from the only known still photographic sequence of Kahlo, were taken in the courtyard of Casa Azul by the Brothers Mayo, a well-known family of photojournalists. *Courtesy C. Stellweg, New York.*

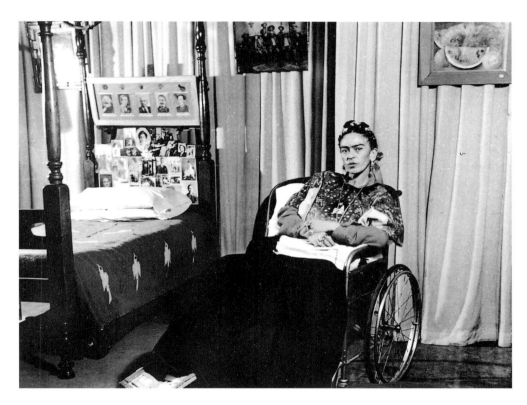

Lola Alvarez Bravo, 1953, Coyoacán, Mexico. Kahlo in her bedroom.

SELECTED READING

Cardoza y Aragón, Luis. "Frida Kahlo." *Novedades* (Mexico City), Supplement, "México en la Cultura", Jan. 23, 1955, p. 3

Chadwick, Whitney. *Women Artists and the Surrealist Movement*. Boston, London, and New York: Little, Brown and Company, 1985.

Freund, Gisèle. "Imagen de Frida Kahlo." *Novedades* (Mexico City), Supplement, "México en la Cultura", June 10, 1951, p. 1.

Garcia, Rupert. *Frida Kahlo: A Bibliography*. Chicano Studies Library Publication Series, no.7. Berkeley: University of California, 1983.

Greuning, Ernest. *Mexico and Its Heritage*. New York: Appleton-Century-Crofts, 1928.

Helm, MacKinley. *Modern Mexican Painters*. New York: Dover, 1968.

Herrera, Hayden. *Frida: A Biography of Frida Kahlo*. New York: Harper and Row, 1983.

Herrera, Hayden. Frida Kahlo: *Her Life, Her Art*. A dissertation submitted to the graduate faculty in art history in partial fulfillment of the requirements for the degree of Doctor of Philosophy, The City Unversity of New York, 1981. To be made available by University Microfilms.

Kozloff, Joyce. "Frida Kahlo". *Women's Studies* 6 (1978): 43-59.

Mulvey, Laura, and Peter Wollen. *Frida Kahlo and Tina Modotti*. London: Whitechapel Art Gallery, 1982.

Museum of Contemporary Art. *Frida Kahlo*. Exhibition catalog. Chicago: The Museum of Contemporary Art, 1978. Essay by Hayden Herrera.

Orenstein, Gloria. "Frida Kahlo: Painting for Miracles." *Feminist Art Journal*, fall 1973, pp. 7-9.

Paz, Octavio. *The Labyrinth of Solitude: Life and Thought in Mexico*. Translated by Lysander Kemp. New York: Grove, 1961.

Rivera, Diego, with Gladys March. *My Art, My Life: An Autobiography*. New York: Citadel, 1960.

Schmeckebier, Laurence E. *Modern Mexican Art*. Minneapolis: University of Minnesota Press, 1939.

Technical Committee of the Diego Rivera Trust. *Museo Frida Kahlo*. Museum catalog with texts by Carlos Pellicer and Diego Rivera. Mexico City, Technical Committee of the Diego Rivera Trust, 1958.

Tibol, Raquel. *Frida Kahlo*. Translated by Helga Prignitz. Frankfurt: Verlag Neue Kritik, 1980.

Wolfe, Bertram D. *The Fabulous Life of Diego Rivera*. New York: Stein and Day, 1963.

Wolfe, Bertram D. and Rivera, Diego. *Portrait of Mexico*. Text by Bertram D. Wolfe. Illustrated with paintings by Diego Rivera. New York: Covici, Friede, 1937.

Zamora, Martha. Frida Kahlo: *The Brush of Anguish*. San Francisco: Chronicle Books, 1990.

ACKNOWLEDGMENTS

The authors and editors wish to thank the photographers who have made this book possible. Many other individuals cooperated in providing prints for reproduction and information for the texts. We especially thank Spencer Throckmorton for his help in bringing together many of the photographs in this volume and for his encouragement and support. Our appreciation also goes to Martha Chahroudi, curator of photography at The Philadelphia Museum of Art; Julie Galant, fotofolio, New York; Evelyne Z. Daitz, The Witkin Gallery, Inc., New York; Joan Stahl, coordinator of Image Collection, Research and Scholars Center, National Museum of American Art; Suzanne Goldstein, Photo Researchers, Inc., New York; Rafael C. Arvea, Centro Nacional de Investigacion, Documentacion e Informacion de Artes Plasticas (CENIDIAP-INBA), Mexico City; and to the following for their contributions and insights: Ava Vargas, Roger Welch, Raquel Tibol, Cristina Kahlo, Hayden Herrera, Sarah M. Lowe, Malu Block, Margarita Herrera, Anna Indych, Angel Lopez, Cathy de Zegher, Marieke de Koning, Alain Mys, and Hilde d'Haeyere.